MONTANA WOMEN

FROM THE GROUND UP

MONTANA WOMEN

FROM THE GROUND UP

Passionate Voices in
Agriculture & Land Conservation

KRISTINE ELLIS

FOR BROADWATER AND GLACIER COUNTY CONSERVATION DISTRICTS

THE
History
PRESS

Published by The History Press
Charleston, SC
www.historypress.com

Front cover, top: Colleen Gustafson, 2017, *courtesy of Ross Campbell, DNRC*; Glenna Stucky, 2000, *courtesy of Rebecca Boulanger, Ampersand*; Dorothy Hahn, 2017, *courtesy of Ross Campbell, DNRC.*
Front cover, bottom; Janet Endecott working cows and calves at her ranch in McAllister, Montana, 2011. *Courtesy of the Montana Stock Growers Association.*
Back cover, inset: Red Angus cow at the Endecott Ranch. The Tobacco Root Mountains surround the lush green pasture, 2017. *Courtesy of Eliza Wiley.*
Back cover, bottom: The riparian pasture on the Endecott Ranch. The pasture was created as part of a three-year stream restoration project done in partnership with the Madison Conservation District. *Courtesy of Eliza Wiley.*

First published 2018

Manufactured in the United States

ISBN 9781467137232

Library of Congress Control Number: 2018932088

Notice: The information in this book is true and complete to the best of our knowledge. It is offered without guarantee on the part of the author or The History Press. The author and The History Press disclaim all liability in connection with the use of this book.

Contents

Contents

Contents

Acknowledgements

The Broadwater Conservation District, Glacier County Conservation District and Montana Department of Natural Resources and Conservation thank all those who have participated in the oral history project From the Ground Up: Montana Women and Agriculture, making this book possible. Their commitment to preserving the stories of Montana women who are passionate about agriculture and land conservation honors the legacy of past and future generations.

ORAL HISTORY PARTICIPANTS 2012 TO 2017

Evelyn Allen Aiken
Eva Hultin Amundson
Wendy Bengochea Becker
Avis Ronning Berkram
Doris Hellebust Bishop
Barbara Broberg*
Jeanette Tomsheck Brown
Connie Amundson Cain
Helen Greutman Carey
Joyce Larsen Dye
Michelle Martin Edwards

Janet Goggins Endecott*
Linda Schwend Finley
Margaret Sanderson Floersinger
Leila "Corky" Johnston French
Helen Hammond Gibbs
Cora Amdor Goggins
Diana Burkhart Graveley
Donna Fritz Griffin
Colleen McGowan Gustafson
Barbara Habets
Dorothy Whitten Hahn

Acknowledgements

Melody Harding
Betty Johnson Hedstrom
Tracy Goerss Hentges*
Judy Forster Hogan
Michelle Geary Holt
Mary Lee Pinod Jacobsen
Lauraine Whitworth Johnson*
Liane Johnson
Margaret Small Julson
Barbara Beers Kirscher
Judith Black Knapp*
Eleanor Baney Koepke
Bonnie Norsby Kronebusch
Peggy Graveley Kude
Donna Nims Lenoir
Esther Johnson McDonald
Andrea Kallen Olenik

Nola Sorenson Peterson*
Arlene Birkeland Pile
Celeste Ward Schwend*
Mary Sexton
Joan Meyer Smiley
Verna Marciniak Sokoloski
Glenna Krueger Stucky
Gloria Van Horn Sundquist
Bonnie Hodgskiss Thies
Georgia Tovatten Tomsheck
Valerie Tuma
Valerie Miller Wadman
Jean Patten Waldbillig
Dana Weatherford
Pauline Adams Webb
Janet Cameron Zieg*

*Past or present members of their local conservation district boards

Conservation District Participants 2012 to 2017

Big Horn Conservation District
Broadwater Conservation District
Carbon Conservation District
Cascade Conservation District
Deer Lodge Valley Conservation District
Eastern Sanders County Conservation District
Garfield County Conservation District
Glacier County Conservation District
Granite Conservation District
Hill County Conservation District
Jefferson Valley Conservation District
Judith Basin Conservation District
Liberty County Conservation District
Madison Conservation District
Meagher County Conservation District

North Powell Conservation District
Phillips Conservation District
Pondera County Conservation District
Powder River Conservation District
Richland County Conservation District
Stillwater Conservation District
Sweet Grass County Conservation District
Teton Conservation District
Toole County Conservation District
Treasure County Conservation District
Valley County Conservation District
Wibaux Conservation District

Introduction

Back in 1978, when Willie Nelson and Waylon Jennings first urged mamas not to let their babies grow up to be cowboys, no one was giving much thought to letting them be cowgirls. Women's experiences in agriculture were largely invisible. No more. There is better recognition now of the value of traditional women's work to the overall success of the ranch or farm, as well as a changing demographic. Since 1978, the number of farms and ranches operated by women has more than doubled, and women operators are the fastest-growing category, according to U.S. Department of Agriculture statistics. At the same time, agriculture is losing vast numbers of farmers and ranchers to retirement.

It was within this context that Linda Brander started talking to conservation district administrators around Montana in 2012 about an oral history project to preserve the stories of Montana women who farm and ranch. A resource specialist with the Montana Department of Natural Resources and Conservation (DNRC) Conservation Districts Bureau, Linda realized that the conservation districts (CDs) were uniquely positioned to capture this part of Montana history before it was lost, particularly women's contributions to land conservation. The state's fifty-eight CDs were created in 1939 to serve as local resources for citizens interested in conserving their soil, water and other natural resources. Through CD research farms, conservation projects and demonstrations, workshops and other educational activities, CD staff work closely with producers to help them adopt the best farming and ranching practices for their areas.

Linda's idea received enthusiastic support from Laurie Zeller, Conservation Districts Bureau chief, as well as Mary Sexton, then-director of DNRC, and the oral history project From the Ground Up: Montana Women and Agriculture became a reality. Two more champions quickly stepped up: Belinda Knapton, then administrator of Glacier County Conservation District, and Denise Thompson, administrator of Broadwater Conservation District, both took the idea and ran with it. As Linda promoted the oral history project on the DNRC website and with special events, other administrators also reached out to the women in their communities. By December 2017, more than fifty Montana women had shared their experiences as farmers and ranchers. From the Ground Up is ongoing, and as additional stories are recorded, they are being added to the oral history collection at the Montana Historical Society. The histories are also available on the DNRC website.

The success of the oral history project led to this book. In these pages, you'll get a taste of Montana agriculture through edited and condensed excerpts from many of the original oral histories, as well as a closer look at how several women perceive their lives and their imprint on their land. Each woman's story is uniquely her own, but the common threads running through all are their passion for farming and ranching and their determination to leave their land better than how they found it. Any reticence about sharing details of their lives was overcome by their desire to promote more understanding of the fundamental need and goodness of agriculture.

As you read what they have to say, you will be struck by their strength and endurance. These are dynamic, intelligent women who love what they do. It is their purpose and their passion, and I am grateful for their willingness to share their stories.

—KRISTINE ELLIS
Helena, Montana
Spring 2018

"The Land Called Me"

Colleen McGowan Gustafson

GLACIER COUNTY CONSERVATION DISTRICT

One beautiful fall day, Colleen Gustafson and her father-in-law were riding home after moving cattle when he reined in his horse and took a look around. "Colleen," he said, "it's worth a lot to be out here on a day like this." She couldn't have agreed more. "Those were such simple words, but they touched my soul and have stayed with me. It truly is worth a lot to experience the beauty and splendor of a blue-sky Montana day from the back of a good horse."

Colleen has spent many a day since on the back of a good horse. She and her husband, Barr, run cattle on Gustafson +3 Ranch south of Browning. Located on cottonwood and irrigated hayfield bottomland along the Two Medicine River, the setting is quintessentially Montana, with high prairie grasses rolling toward the distant Sweet Grass Hills to the northeast and the spectacular Rocky Mountain Front rising in the west. "Sometimes the beauty of it all can cause a physical pain and, at the same time, a spiritual and emotional exuberance in me," said Colleen. "I think an intrinsic bond with nature is part of the human condition, and those of us in production agriculture are blessed to be able to build on that connection throughout our life's work."

That bond runs deep in Colleen. Growing up on the family farm in the Highwood Valley east of Great Falls, Colleen always preferred being outside, even refusing to go to kindergarten because she was too busy "helping" her dad with the cattle. When she attended Montana State University to study

Colleen Gustafson repairs a damaged fence, 2017. *Courtesy of Ross Campbell, DNRC.*

agriculture business and economics, her friends teased her about her frequent trips home: "They claimed that I would rather plant seed with my dad than party with them, and it was true. The land called me. I had several favorite places that I liked to ride or hike to, to just sit in the grass and connect to the land. But I also loved the work and felt a very strong need to show that I was capable of doing it. I wanted to keep my foot in the door."

Like many generational farm families, Colleen's parents, Duane "Bo" and Sharon McGowan, faced the dilemma of knowing that two of their three children wanted to remain part of an operation that could only support one family. Despite that reality, and even after moving to Idaho to work as a loan officer for Farm Credit Services after graduating from the university, Colleen still believed that she would eventually end up back in Highwood on the farm. Then fate intervened in the form of Pat Gustafson.

Colleen met Pat, her customer and future mother-in-law, when she transferred to the Farm Credit Services office in Conrad. Pat surreptitiously set Colleen up with Barr by inviting her to help trail cattle to summer pasture. His only question when his mother asked if Colleen could go along was "Does she ride?" Colleen found it all pretty embarrassing. "But after more than twenty years of marriage, a beautiful ranch, great in-laws and two wonderful kids, I am happy that it all worked out as it did," she said.

Colleen and Barr married in 1992, and she describes the first few years on the ranch as "magical." Pat and her husband, Rib, had purchased Gustafson +3 Ranch in 1971 and partially retired to their home in Conrad when Barr returned to the ranch to live and work full time. After Barr and Colleen married, he continued to work for his parents on the ranch as well as manage his mobile veterinary practice, and she became the agricultural loan officer and vice president of lending at Blackfeet National Bank in Browning. Rib and Pat continued to live in Conrad but spent considerable time at the ranch as well. As time passed, the realities of life on the ranch made Colleen increasingly unsettled. Money was tight, and a significant portion of their outside income was going into the ranch without any consideration of future equity. "Pat and Rib established a trust for the land and other ranch assets that gave each of their five children one-fifth undivided interest upon their death. With my banking experience, I knew this situation could be a recipe for disaster," said Colleen.

She started talking to the family about estate planning, which proved to be difficult for Barr. "He believed that I was pushing too hard to make a change at the expense of his family, and I was hurt that he was pitting me against the family." Although Barr came to appreciate her position, the process was stressful for everyone. "It still makes me sad to think about that time," said Colleen. "It can be so difficult to balance family loyalty with sound business decisions. Fortunately, Rib and Pat, along with Barr's sister, who is a law professor, saw the need to update the estate plan." The family was able to agree to terms that assured financial security for Pat and Rib and allowed Colleen and Barr to purchase the ranch at a price that recognized their past financial contributions and Barr's unpaid salary for his years of labor. "It wasn't easy for Barr's siblings to face not owning the ranch, which they loved," acknowledged Colleen, "but we all worked hard to get along."

Colleen and Barr bought the ranch from his parents in 1998 and now have access through deeded property and leases to about twelve thousand acres. They generally run about 350 cows. Colleen describes their approach to cattle production as straightforward: good nutrition and enough space. They limit vaccinations to an "8-way" vaccine at branding, which prevents terminal diseases caused by Clostridia bacteria commonly found in the soil and intestinal tracts of animals. They add a preconditioning shot in the fall only if absolutely required by their cattle buyer. "Barr firmly believes that sound genetics—a moderate-framed cow, moderate birth-weight bulls—and excellent nutrition far surpass any vaccination program," she said. To facilitate good nutrition, they keep their rangeland in excellent condition, put up dryland and irrigated

alfalfa mix hay and feed their cows to keep them in good body condition year-round.

The Gustafsons use as few chemical inputs as possible, focusing instead on maintaining a healthy ecosystem in their native range and cottonwood and willow river bottoms. "So we must graze responsibly," said Colleen. "We use rotational grazing when possible, although access to water does limit how much we can do that. We try to only use summer pastures for thirty days and rotate which pasture we use first. Overall, our mantra is 'take half, leave half.'" Their biggest problem is the rampant knapweed beyond the ranch's boundaries. Few neighbors in their area work as aggressively to fight noxious weeds. To combat the explosive growth, the Gustafsons have turned to biological weed control, releasing insects that are the natural enemies of the weeds. "There are constant reinfestations of our land via wind, water and the roadways, so we think that having well-established biological controls might be our only feasible long-term defense," said Colleen. Roaming horses are another issue. "There are thousands of them and thousands of acres of land here that have been grubbed down to rock. Our ranch is pretty spread out, so we don't see areas of it for days or weeks at a time, and it is very common when we do to find gates open and horses eating the grass," she

Colleen Gustafson follows behind the seeding tractor to compress hay seed into the soil and level a hayfield, 2017. *Courtesy of Ross Campbell, DNRC.*

NOLA SORENSON PETERSON
HILL COUNTY CONSERVATION DISTRICT

Nola Peterson and her husband, Kim, own the Peterson Grain and Cattle Ranch northwest of Havre.

"Every day I get a sense of wonder. We live where the seasons are so different. It can be really hot in the summer and frigid in the winter. But no matter what the season, there is always beauty out there. In the fall, for example, it is so quiet. Traffic seems to have slowed down on the highway, the machinery is put away and there are days that you can actually hear silence. In a lot of places in this world you won't hear that. I've been around agriculture my whole life. It is just something that is inside me. I've enjoyed what I do, and I would like to leave that feeling to my family—that they always be happy when they get up in the morning and do something that they love to do."

said. "They are feral unbroken horses with no place to go and nothing to eat but another rancher's grass."

Given their proximity to the Rocky Mountain Front, the Gustafsons also have encounters with grizzlies. "We usually have five or six grizzly bears roaming around, and there has been one in particular that has no fear. It's been in the yard and corral, and has broken windows in a building. We love to see them—we'd just rather see them in Glacier Park." Still, Colleen adds, "They are part of our landscape and we need to respect that." Having grown up with them, the Gustafson children, Greta and Owen, learned to take the bears in stride, at least to a point. Colleen tells a story of when the kids were young and saw grizzly tracks in an area along the river where they built forts. After lunch one day, the kids went out to their forts, then quickly ran back to the corral where their parents were working to report fresh grizzly tracks. Colleen told them that they had to play around the corrals or in another area where there was a grove of trees that they called the jungle. "A couple of days later, Owen came inside and said, 'Oh great, the grizzly bear tracks are all over the jungle and the corrals. Now where are we going to play?'"

Because Colleen and Barr don't have hired help, Greta and Owen grew up with a lot of responsibility. "I think seeing Barr and I work so hard has

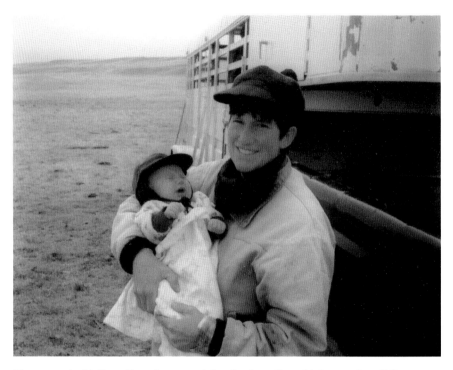

Three-month-old Greta Gustafson attends her first branding with her mother, Colleen. Greta spent most of her time in her car seat in the pickup, guarded by the ranch dogs, Rufus and Lick, 1998. *Courtesy of Gustafson family.*

certainly influenced the excellent work ethic both of them have. It's also helped them be mature, independent and resourceful," she said. "We had codes when they were young because they were left alone a lot. If we were moving cattle or had to leave early in the morning, we'd leave breakfast for them in front of the TV with cartoons on; that was the code for 'everything is okay and Grandpa Rib will be here soon.'" There were no typical family vacations, such as a trip to Disneyland, but a wealth of good times together. "They were always with us," said Colleen. "If Barr and I were fencing, say, we would picnic in a coulee or next to a stream, and they always thought that the picnic was the reason we packed lunch. They didn't know it was because there wasn't time to stop working and go home." As very young children, both Greta and Owen loved going out at night to check the heifers during calving. "If the weather is decent, it is magical," said Colleen. "You hear the river more clearly, and they learned about the stars and the constellations. They also learned firsthand about birth and death and saw the immediate maternal bond between the cows and their calves."

The family has had its challenges, of course. Birthday parties, sporting events, family gatherings and more have been missed because the ranch comes first. And Colleen is frank about the friction that can erupt when spouses work together, especially, she says, when cows are added to the mix. "Many of my women ranch friends and I agree that men can immediately go insane when cows are in the corral and need to be worked," she laughed. "But I guess we work it out because most of us are still married." Even so, she believes that agriculture has been at the forefront of gender equality for a very long time. "Maybe more so in ranching than farming because of the nature of caring for livestock," she said. "If a job needs to be done, whoever is available has to do it." Barr and Colleen generally work together when both are home. At certain times of the year, Barr's vet calls mean that he is rarely home during daylight, such as during pregnancy testing season in the fall. "I get to do things my way then," said Colleen. "The rest of the time he considers himself the boss, and there is his way or the wrong way, and that can be difficult. But I have a network of friends and neighbors who think I'm a pretty good hand, and that helps." Some of her friends have asked Colleen why she just doesn't walk away and let Barr do the work himself when tensions are most high, but she is practical. "I know we'd have to finish the job the next day, so it's never seemed worth it to walk away from a task."

In the years since they purchased the ranch from Rib and Pat, the couple has been able to upgrade much of their equipment, making the physical work easier and more efficient. Instead of an old cabless swather, they now have one with air conditioning. A hydraulic post pounder makes fencing easier, and a decent used pickup now pulls the stock trailer. Feeding has gotten easier as well with the move from small square bales of hay to large round bales. The smaller ones required that someone feed from the back of the flatbed and someone else drive; Colleen now takes the pickup and Barr the tractor to feed large round bales. The Gustafsons have also added four-wheelers, which made a huge difference for fencing and other chores. "We still rely primarily on horses for our cow work, but we often load a four-wheeler and a horse into the trailer. You can cover so much ground so fast locating cattle on the four-wheeler and then use a good horse to get them where you need them to be," said Colleen.

Colleen's connection to her horses is primal—they are her partners, not her pets. "They are such strong, magnificent creatures, and it is astonishing that we can control their movements with just the slight pressure of our legs or on the bit. Working in tandem with them is pure joy. And placing

Eleanor Baney Koepke
Glacier County Conservation District

Eleanor Keopke and her husband, Donald, raised three children on their ranch outside of Cut Bank.

"You know, farming life can get hard at times, but you just have to be strong and keep going. Because tomorrow is a new day. The good days have always outweighed the tough ones, and with the Lord's help, we always made it through."

your face in a horse's neck and breathing in their scent is one of the most satisfying things there is," she said. Her dog, Maggie, might feel the same about Colleen, preferring to be anywhere she is. "I just can't look at her without smiling." Her children tease Colleen that she loves her animals more than them, but she takes the point seriously. "Ranching can be a lonely life," she said. "I can go days or even weeks without seeing anyone other than Barr, Greta and Owen. The animals are always here and living in the moment, and that is a beautiful thing." Colleen describes the newborn calves as being "like Bambi and Thumper on the ice. Clumsy, stumbling as they learn to use their legs, and then all of a sudden able to put their tails in the air and run. It is such a pure experience of the miracle of life....A cow can sniff through a hundred calves and know without a doubt which one is hers. You get a real serotonin rush watching it."

Colleen views her connection to animals as a driving force in what she hopes will be her legacy. "The animals always come first," she said. "You take care of them to the best of your ability. You also respect the land and try your best to keep it viable and healthy." To that end, the Gustafsons live frugally. The house is heated with wood; there's no dishwasher and only one small television; they finally bought a clothes dryer but still mostly use the clothesline and drying rack; and the outhouse worked just fine, thank you, for all those years before a new septic system was installed. "These are lifestyle choices that tie closely to our feelings about conservation and limiting our contribution to the landfill problem by recycling and conserving," said Colleen. "I think that conservation should be a daily matter regardless of lifestyle."

It is an area in which she believes farmers and ranchers often go above and beyond without sufficient recognition from those outside the industry. As a result, the public is misinformed at best and sometimes unnecessarily antagonistic at worst. "I think that the biggest challenge for agriculture now is public perception. It is crucial that we get our story out there," she said. "Most farmers and ranchers care for the land and are the reason that there are abundant wildlife and bird populations, healthy streams and rivers, and wide-open spaces." Colleen would like more people to see the potential partnerships among ag people, environmentalists and other user groups. "I think that people on the fringe are the loudest, so they are heard the most," she said. "It is true that some ultraconservative ag people are unrealistic about federal lands and property rights and that there are the ultra-nut environmentalists. But I think most of us are all on the same side. We all need open space and clean air and water."

Colleen is involved in numerous ag organizations as a way to be part of closing the perception gap between agriculture and others, as well as to keep the needs of those in agriculture in the forefront at a time when the number of farms and ranches in the United States is shrinking: "One

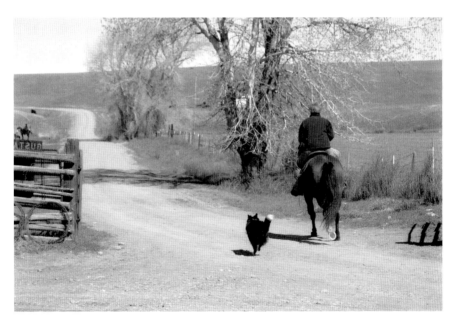

Colleen Gustafson and her dog, Maggie, head down to the Two Medicine River to check on cow and calf pairs. Colleen is on her son's horse, Scotch, 2017. *Courtesy of Ross Campbell, DNRC.*

of our challenges is that we can lose our political power just as a result of fewer numbers. Things like the American Prairie Reserve, which is buying up ranches in eastern Montana, are kind of like drought—it's there and we have to deal with it. So people need to stay active. Being belligerent doesn't work, we need to respect others' views, but we need to be heard."

Colleen also continues to advocate for estate planning in much of her volunteer work. "I'm passionate about this. The elder generation of farmers and ranchers have to have a transition plan for their businesses, and it has to be open and transparent regarding the financials so that both the on-farm and off-farm children know what is going on." She also encourages parents to start talking to their children about transition planning as soon as they are old enough to understand, which, given her own experience with their daughter, Greta, could be sooner than parents might think. "Greta was probably four or five, and we were outside doing something. She started waving her arm around the expansive horizon and said, "Mom, someday when I'm grown up and you and Dad are dead and all of this is mine, we're going to have to move the [bunkhouse] and move the barn over here, because I want my arena where the barn is."

ESTHER JOHNSON MCDONALD
GRANITE CONSERVATION DISTRICT

In the early 1950s, Esther Johnson moved from her mother's ranch in the Bitterroot to her husband's family ranch near Philipsburg when she married. Over the years, she has been very active in organizations such as Montana Cattle Women and the Montana Farm Bureau, frequently testifying before the Montana legislature.

"My mother was a politician, so I come by it naturally. We had a big Farm Bureau group, and the women were very active in it. The men couldn't go testify because they had to feed the cattle, but we'd go to Helena and testify on hearings. I think we acquired a lot of friends throughout the state because we were all for agriculture. But we had to fight for our water rights, our property rights and all that, and we did. A lot of people aren't cognizant of the legislature now, but you have to make yourself heard."

Both Greta and Owen want to return to the ranch as adults. "It's always been our rule that the kids have to have a degree of some type and work for someone else for several years. Then if they want to come back to the ranch, we will do all we can to make that work," said Colleen. She and Barr have encouraged their children to reach out to new experiences to help them become thoughtful adults. Greta has traveled to Europe several times to visit friends of the family and immerse herself in different cultures, and visitors from near and far are always welcome at the ranch. "We've welcomed many guests, and I feel that maintaining contact with people from diverse backgrounds and cultures is so important for staying open-minded and aware of the big world beyond the ranch," Colleen noted. She points out that if production agriculture is one side of the equation, eating is the other. "Serving our grass-fat +3 beef to guests from all walks of life is such a tremendous opportunity to promote agriculture. As a double bonus, I love to cook and it is rewarding to share that with others."

Colleen and Barr purchased a small ranch about thirty miles from the +3 Ranch that can serve as their retirement home should they one day step away and let their children take over. Until then, Colleen fills her days loving what she does. She hopes that some day her future grandchildren will remember her as a good mother and hard worker who cherished her family above all else, with the ranch and the animals a close second. "I also hope they know I believed that no matter what grand things a person accomplishes in their lifetime, being kind is the grandest thing of all—and that I loved turquoise jewelry and rode really good horses."

"It's Better to Wear Out Than Rust Out"

Arlene Birkeland Pile

SWEET GRASS CONSERVATION DISTRICT

A natural-born storyteller, Arlene Pile knows how to put a lifetime of attitude into every tale—like her story about the time she was almost drowned by her four-wheeler. Arlene had two irrigation dams to place that day. Each dam is a piece of poly material about eight by ten feet with a four-inch pipe inserted into the sleeve at the top. Arlene installed the first dam just as she had done hundreds of times before. She placed the pipe across the ditch, and when the material spread out across the flowing water, she stepped on the upstream edge to allow water to flow in and hold the dam in place. Mission accomplished, she was ready to move on to the next field and the next dam. But first she had to back the four-wheeler up the slope she had driven down to get closer to the ditch. She explains what happened next:

"I climbed on and fired it up, then put it in gear and started to back up the bank. Well, the dam snagged in the chokecherries, and the next thing I know I am in the ditch and the four-wheeler is on top of me. My head's stuck in the mud and the water, and the tire is a'goin just as fast as it can go. It's just screamin' loud and it's just shootin' mud and water and burying me in that ditch. And I thought, oh my goodness, I could die here. In order to get out, I had to get really mad so I could kind of lift up the four-wheeler and squirm out from underneath it. I was covered from top to bottom with mud, but I fished myself out of there and shut the four-wheeler off. Gas was drippin' out of the tank so I had to do something. I left it upside-down in the ditch, climbed out over the edge of the ditch bank and walked to my house a short

At eighty-two, Arlene Pile still loves taking her four-wheeler out to check fences, watering holes and the overall condition of the EOB Ranch, 2017. *Courtesy of Ross Campbell, DNRC.*

distance away. Well, no one was there, but the hired man had a vehicle there and I got in it and I went and got him and I told him, 'We have a situation.' He took one look at me and says, 'I believe every word you're sayin'.'"

Arlene was sixty-four at the time, and although this was the closest call she's ever had, it would not be her last exceptional experience on the EOB Ranch. Nearly everything of value to Arlene flows from this piece of land. It is her very foundation and fills her with a sense of "belonging, knowing, being familiar with everything and finding contentment in that knowledge." It has also been the proving ground of her family—past, present and, she believes, future—providing a way for them to live well and with integrity. "I want that word to be important to everyone because it is a good way to live," she said. "My family practices integrity all of the time. Agriculture presents that. It challenges your sanity sometimes, but it sure is a good life."

Located on Lower Deer Creek in Sweet Grass County, the EOB Ranch gets its name from Arlene's father, Eystein O. Birkeland. Eystein was born on the ranch in 1900, three years after his parents, Ole and Inga, settled there. Arlene has a nearly tangible connection to those who came before her. "I sense their presence here a lot," she said. Inga, in particular, looms large,

DORIS HELLEBUST BISHOP
PONDERA COUNTY CONSERVATION DISTRICT

Doris Hellebust's parents emigrated from Norway in the early 1900s and homesteaded in northern Hill County, where she was born in 1926. Doris and her husband, Argyle Bishop, live on A.U. Bishop Ranch, outside of Brady.

"Those were the hard years, the 1930s. There was dust bowls and grasshoppers and drought. I think the hardest part was not having any hope. You didn't see any chance for it to be better. About 1934, my parents joined the Montana Farmers Union. They were working at the time in developing cooperatives. People could help each other by joining together to buy oil and gas and elevators to sell their wheat. Before that time, no farmers knew you could get paid for protein. The elevators and grain companies never let anybody know. When they formed their own cooperatives, it was a leap ahead. They persevered; my folks stayed strong. I was too young to be able to comprehend it all, but those were hard times. God carried us through those times, and we had a good life. Really, I've had an exceptional life.

"I think the woman pretty much sets the tone for the family life. You either get optimistic or you get dragged down; you can go up or down. I think you set the tone because you are with the children all the time. You influence how they look at life, how they treat one another, all kinds of things. We eventually had four girls and one boy. Our children were willing to help always. I think all of that is catching. On a farm, where you can create your own environment—you really have that privilege of doing that—it makes it so important that you give a strong positive feel. Our girls always helped with all parts of the farm; there was no division. Nobody said, oh, that's not my job. We were strong believers in cooperatives for all farmers, but also cooperating at home. During the early years of Farmers Union, we had a teacher who said it was important to know about weeds in our fields, weeds in ourselves and weeds in our country and to try and fight against all of those. I've never forgotten that."

although she stood just five feet, two inches tall. "She was an exceptional lady," said Arlene. "I liken her to a little lady who managed life with a velvet hammer. You knew very well when you were being jerked up by her."

Inga and her brother, Jacob Hoyem, came to Montana in the late 1880s to raise sheep. A few years later, she married Jacob Halverson and had a son and a daughter. When her husband developed pneumonia, Inga insisted that the family travel to Norway so Jacob could receive medical care, but he eventually succumbed to his illness. Inga's parents then helped Inga and the children return to Montana. Once back, Inga met Ole, a "newcomer," or recent immigrant, who was working for her brother. As Arlene describes it, "Ole took a shine to her and Inga took a shine to him, and they married and moved across the river." A few years later, they moved again, this time up the creek drainage to what would become the EOB Ranch. Ole and Inga put together a sizeable place over the years, adding to the original 160 acres by acquiring adjoining property when drought and the Great Depression forced out their neighbors. Today, the ranch has about 20 miles of boundary fence and covers anywhere from 3,000 to 4,000 acres with Bureau of Land Management (BLM) and state land leases.

Arlene's parents inherited the ranch in the late 1930s. Eystein had married Isabelle Todd in 1934, and with the passing of his parents, the couple took over considerable debt along with the land and livestock. The situation became even more dire in 1946 following a die-off of four hundred sheep. The flock had been grazing on national forest land and was being trailed back to the ranch when the animals started moving downhill too fast to control. Before anyone could divert them, the sheep got into an area near the creek lush with lupine. All ate heavily of the toxic plants and died within twenty-four hours. "That was the first time I saw my dad cry," said Arlene. "And then I learned what buzzards were, cuz it didn't take them long to zero in on them. The coyotes and the buzzards cleaned 'em up."

Given the grief and a low market price, Eystein decided it was time to get of out the sheep business. The transition to cattle presented its own challenges but saved the Birkelands the cost of hiring sheepherders. Eystein and Isabelle could handle the cows on their own, and by then, Arlene and her sister, Gail, were also integral to the operation. Born in 1934 and 1938, respectively, the girls were hard workers. "Mother always wanted a gang of boys to do the ranch work, but she didn't have that so my sister and I learned to be her gang," said Arlene. "We just took on anything. Dad's motto was, 'If you set your mind to it, you can do whatever you want,' so I didn't know there were things that I couldn't do. Although age tells me now that there

Arlene Pile's ancestors (*left to right*): great-grandmother Olina Hoyem, unknown, Olina's daughter-in-law Ashbjorg Hoyem and Ashbjorg's daughter Ingrid. *Courtesy of the Pile family.*

are." Isabelle was an outdoors woman and left much of the inside work to her daughters. "She worked side-by-side with my dad, taking care of cattle and riding horses and doing other outside work. So as soon as I was big enough to see over the edge of the sink, I stayed in the house and cooked," said Arlene. Even so, from as long as she can remember, she's been able to run machinery and ride horseback.

Arlene learned how to drive on an 8N Ford tractor equipped with a buck rake, which leads to another tale of another wreck: "One of my first jobs was to rake hay. We have hayfields on benches with steep hillsides that go down to the creek. I was day-dreaming one day, not paying attention to what I was doing, and drove off one of those fields. Well, the front end of the tractor's hanging up in the top of the chokecherry trees, and the only thing that's keeping it from falling all the way down is the fact that the buck rake teeth kind of gouged in the ground. So I very gingerly climbed off of the back of the tractor and walked back to the house. I knew the folks were in the house and I didn't want to tell them what I'd done, so I crawled in the window of my sister's bedroom and got her out so she could come and help

Avis Ronning Berkram
Glacier County Conservation District

Avis Ronning grew up in Libby and moved to Cut Bank after her marriage to Kenneth Berkram.

"Ranching and farming have been my whole life. It wasn't always easy, but you do the best you can with what you've got. I have a strong love for nursing and family, and farming allowed me time to do both. I will go out of my way to help neighbors in need. You never know when you might be that neighbor in need."

me pull that tractor out of that chokecherry bush. We didn't tell the folks about that for many, many years."

Located about fifty miles from Yellowstone Park, the ranch shares the hilly yet beautiful geology of the area. According to Arlene, the pasture can be described as "up and down." The largest hayfield on the ranch is about eighty acres in size. Lower Deer Creek cuts across the middle of the ranch and serves as the primary water source for irrigating, which has been Arlene's lifelong passion, despite mishaps. "I love to turn the water onto the fields in the spring," she said. "The plants develop a little bit of a gray appearance on their tips when they grow, but when the irrigating water hits, it transforms them. You can just see the plants changing as the water runs across the field. It is positively mesmerizing. I call it magic."

Arlene gave up irrigating for a while when she married Clarence "Bud" Pile in 1953 and moved to Fort Knox, Kentucky, where he completed his two-year tour with the U.S. Army. The couple had met at a competitive shooting event when Arlene was a freshman and Bud a senior at Montana State University. Following his military discharge, Bud, Arlene and their newborn, Eleanor, went back to the ranch for a visit, where one thing led to another. "They needed help. Dad was feeding a bunch of heifers and calves, and he had to grind a bunch of hay every day to do that. So we just started helping and never left," said Arlene. The decision benefitted them all. Working the ranch was becoming difficult for Eystein, and he and Isabelle were considering leasing the pastures for income. For their part, beyond the visit, Bud and Arlene had no set plans. Bud had always assumed that he would take over his parents' beekeeping business in the Bitterroot Valley.

Then, a week before he and Arlene married, Bud went into anaphylactic shock when he was helping his dad extract honey from the bee frames and had to be hospitalized. His deathly allergic reaction ruled out any future in beekeeping, so settling in at the EOB Ranch gave the young family a future and kept the ranch under family management.

Arlene and Bud raised two children on the ranch, and Arlene describes both their daughter, Eleanor, and son, Jim, as deep-rooted pioneers and very much agrarians. "I think that there is a strong genetic propensity for it," she said, adding that it comes from the Todds as well as the Birkelands. "My mother could make soup out of a rock. She just knew the ways of nature and what to do to make it all work. And my dad had a gift with animals." Both Eleanor and Jim took to the life early on. Eleanor, for example, begged for a milk cow when she was four years old. She got that along with several more calves over the years, while her high school graduation present was a tractor she still owns. Jim was fascinated with growing plants as a child, as well as with machinery and building. He continued his life passions after moving to Virginia in the 1980s. In addition to growing heirloom vegetables and beekeeping, Jim earned a stewardship award for his management of a

Arlene Pile at age fifty-six and the tractor she gave to her daughter as a high school graduation gift, 1990. The mower/conditioner towed behind the tractor cuts and crimps the hay stem, which helps cure and dry the mowed grass. *Courtesy of the Pile family.*

historical farm and restoration of native quail populations before his death in 2016 from complications of lupus.

Arlene and Bud were married for thirty-two years. A series of presents from Bud sums up their working partnership: "He bought me a saddle for my birthday, a pair of chaps for Christmas and a pistol for my next birthday. I've made good use of them all, but I was happy to retire the saddle and the chaps." Bud and Arlene divorced in 1986. Although she ended up with the ranch, the split left Arlene without the resources needed to keep the operation going. Not willing to walk away, she decided to lease out the pastures and supplement that income with other sources of revenue to keep afloat. Her first job was as a bookkeeper for the Big Timber Airport, something she admits had as much to do with her love of flying as the need for a paycheck. Arlene also operated a seasonal bed-and-breakfast for hunters on the ranch for ten years and, in 1997, worked as a certified nursing assistant at a nursing home for a year while her grandson—Eleanor's son, Josh Fjare—and a friend of his lived with her and finished high school. "We all took jobs off the ranch," she said. "During the day, the boys went to school, and then they both went to work until 8:00 p.m. We'd have supper together and then I'd go to work at 10:00 p.m. and come back at 6:00 a.m. We did that until they graduated and my grandson went into the military and the other young man went to Spokane."

During the years she leased the pastures, Arlene kept her hand in ranching by initiating and monitoring land conservation, which primarily related to pasture rotation. "I didn't put up any hay at the time, and you don't leave cattle on irrigated fields indefinitely, so it required fencing and moving cattle and using minerals and salt to attract cattle to different portions where the feed was the best. I'd buy the material and [the lessees] did the work," she said. More recently, the conservation practices implemented at the EOB have been triggered by severe wildfires in 1994 and 2006. Both required evacuation, something that didn't sit at all well with Arlene. "I had a strong need to apologize to my ancestors," she said. "I felt like I was not doing what I should be doing in their eyes. But when the sheriff is standing there telling you to clear out, you do it."

In the aftermath of the fires and drought, the family has had to deal with weeds as well as erosion on denuded hillsides. They have made good use of biological weed control and reseeding, with more work to do. Managing stream flow during spring runoff is another ongoing task. Although Arlene has worked with a hydraulic engineer on various projects to slow the velocity, the Lower Deer Creek is a powerful adversary. "There is a two-hundred-foot

ANDREA KALLEN OLENIK
BIG HORN CONSERVATION DISTRICT

Andrea Kallen Olenik lived near Hardin and the Big Horn River for nearly a century before passing away in December 2017.

"When I was born, everyone was poor. But we had a big garden and fruit trees and hogs and beef, and that's how we kept going and how I grew so healthy. We worked hard, but we had time to play. We milked as many as seventeen cows back then. Of course, we sold the cream. And oh, did I make butter! I sat down in the basement with one of those glass churns, and I was churning so hard that it hit the concrete and broke. I graduated from high school in May and got married in June. I did chores, and chores meant get on the horse, go get the cows, get the milk separated, feed the pigs, feed the chickens, everything. There was always a lot of chores along with everything in the house. Then along came the kids. Early in the morning till ten o'clock at night you were working, but it was fun. Looking back, it was fun."

drop in elevation in the creek over two miles of the ranch, and when the volume is equal to that of the Yellowstone, it takes its own way," she said. The emphasis, therefore, has been on slowing and spreading out the water. Strategic arrangement of rock already in the creek can create a sandbar that will help slow velocity, as will encouraging willows to grow on the sandbar. Diverting water for irrigation also helps.

These days, Josh and Eleanor manage the EOB Ranch under a limited liability company Arlene formed to pass ownership on to the family. Her grandson Cameron Pile, Jim's son, owns property adjoining the EOB Ranch that was once owned by his grandmother, Isabelle. Surrounded by her loved ones, Arlene now calls herself a "fixture" rather than an active rancher, but the term is a little staid given the reality of her presence. Arlene still helps out by driving truck, working cattle, spending time with her great-grandchildren and, of course, irrigating. As she says, "It's better to wear out than rust out." Like her offspring's genetic propensity for working the land, rugged resiliency seems to be a family trait as well. Arlene likes to think of her daughter, for example, as a girly-girl with steel pants. "She's tough. Her

husband once made the remark that he always wanted a woman who'd kill her own clothes, and that girl can do it. She's extremely capable as well as beautiful, smart and hardworking."

It runs right on through to the youngest generation. One of Arlene's proudest moments was watching her thirteen-year-old great-granddaughter, Morgan Fjare, save a newborn calf on a wet, nasty day: "The calf was chilled, and the cow didn't care whether he paid any attention to her or not. And here's this girl out there dragging a sled behind the four-wheeler. You could see the grit there. She's mud from one end to the other, but she wrestled that calf onto the sled and got him back to the barn and into a pen where there was straw. She got him dried off, but he didn't look like he was going to make it. So she rubbed and shook him, trying hard to get him to come alive. Finally, that calf started to show signs of life, and we dribbled a little milk into his mouth. I was so tickled with the excitement she displayed. Pretty quick, he brightened up, and before the day was over, he was chasing her out of the pen."

Arlene hopes that Morgan and her brother, Wyatt, will keep the EOB Ranch going long into the future, but she is content to let them get there in their own way and at their own pace. Overall, she is optimistic about the

The Pile family posing for their Christmas card, 1970. *Courtesy of the Pile family.*

future. She would like to see women get more credit for their contributions to agriculture, calling them "the glue that holds it all together," and she would like people who aren't in the business to understand the lack of parity between what a rancher or farmer produces and what it costs to make that happen. But even so, Arlene takes the long view. "If I'd stuck strictly to numbers, we'd been gone long ago," she said. "You learn to ride the rough spots. It's hard for young people right now just starting out because of the challenges they face, but I want them to take heart and not be frightened. Things will get better."

"I Guess I Didn't Realize How Much Push I Had"

Eva Hultin Amundson and Connie Amundson Cain

LIBERTY COUNTY CONSERVATION DISTRICT

Eva Amundson and Connie Cain died within two months of each other in 2017 at the ages of 106 and 86. Mother and daughter, these were quick-witted, compassionate women who laughed easily and often. Their personalities differed, but they shared an intelligence and intuitiveness that made them both exceedingly capable. No whining allowed. If something needed to be done, just do it. Simple as that. And yet, such perseverance—or gumption, as Connie would say—isn't simple at all. Not everyone made it through the Dust Bowl without losing their land. Not everyone approaches change confident in themselves. And certainly, not everyone has the determination Eva had to help transform cultural perceptions of people with disabilities.

Their story begins when Eva's parents moved to Montana in 1911. Like so many others in search of a new start, Elmer and Alma Hultin heard the tales spread by the railroads of free land covered by high grass and decided it was their chance to make it big. What they didn't understand was how hard it would be. How far they would be from anyone else on their homestead sixteen miles from Joplin. How they would have to start from scratch for everything. And how, more often than not, prairieland in northern Montana was dry and windblown rather than green and lush. "They thought it was going to be wonderful because they would own a half-section of land, but it was terrible," said Eva. "So many people starved out there. In those days, nobody knew how to farm that country.

My parents came from North Dakota, where my dad was a jeweler and a salesman. He was a very poor farmer."

Eva was just a few months old when Elmer and Alma brought her and her two brothers west. Although her parents didn't talk about those times, Eva believed that they came with some savings, as they were able to have a two-story frame house built, as well as a granary and machine shed. "A builder from Norway was their neighbor, and he must have built the house, because it was a very good house," Eva said. Once settled, it was a harsh life. They farmed with a pair of oxen and had a couple of horses, some chickens and a few cows that Eva remembered milking as a child. "I don't remember my parents ever saying they regretted the move, but us kids weren't happy. It was hard, we had to make do with what we had, and that's all there was." She remembered walking barefoot to pull weeds along the half-mile rows of flax her father planted because "if you wore shoes, it would wear them out."

Alma and Elmer had four more children after Eva, and Alma was determined that they have the opportunities and options that come with an education. One of Eva's strongest memories on the homestead was the day her mother stood up to her father over the issue: "My mother was a very smart person, although she didn't voice her opinion much. My father was

Eva Amundson and her daughter, Connie Cain, at the Springs senior living center in Missoula. Connie, 86, traveled five hundred miles from her home in Broadus to celebrate Eva's 106th birthday, 2017. *Courtesy of Linda Brander, DNRC.*

VERNA MARCINIAK SOKOLOSKI
WIBAUX CONSERVATION DISTRICT

Verna Sokoloski was born in December 1914 and died at age one hundred in August 2015. Raised on a farm in Wibaux County and one of six children, Verna was four when her mother died. Her father then married his sister-in-law, and the couple had seven children. After graduating from eighth grade, Verna stayed home to help with the younger children until she was eighteen. She was in her teens when the Dust Bowl hit.

"I remember they were very dry years and that we couldn't even make hay. They had to make hay out of thistles. They put molasses on the thistles and the straw, and then you better not be behind the cows. We still tried to raise our gardens and milk cows and chickens. That's what kept us going. My folks always raised chickens and geese and ducks. I know one year we had about fifty geese. Mom made feather pillows. And we had an icebox; the top of it was where we put the ice, and then the bottom kept everything cold. My dad used to cut ice on Beaver Creek and drag it to our icehouse. We put some coal slag over the ice and then straw on the top, and the ice would keep all summer. When we needed it, we'd go there with a wheelbarrow, and then we'd take it to the pump and pump water on it to clean it off. Then every Sunday we made ice cream with the cream from the cows. It was really good

"Stanley and I didn't have much when we married; we just had each other. But Stanley worked and later got a carpenter's job, and I stayed home and worked and raised the garden. I raised some chickens, and my dad gave me a cow so we could milk. Then she had a calf, and we started a few cattle, not too many. We went out every Saturday night. Stanley was really a good dancer. He wouldn't dance with nobody else but me, and I got to dancing like he danced, so you know, we danced a lot. One time there was this waltz contest at Jack's Club, and people came from all around—Dickinson, Baker, Glendive. That town was just packed. And Stanley and I won first prize for waltzing. We got twenty-five dollars, and at that time, this was in the fifties, that was pretty good."

the boss, and women weren't supposed to have any mind at all then. But the one thing she defied my father on was that he was not going to keep my brothers home from school to work for him. So she went out and harrowed the field, and the boys went to school with us in Joplin. It made all of us kids aware that we were equal, that women weren't inferior and they could contribute as much as men."

All of Alma's children but Eva would eventually put themselves through college. She took a different path by marrying right out of high school. Leif Amundson grew up fifteen miles from Eva's family. He'd dropped out of school to work his family's farm when his father died in 1923, but when Leif and Eva married in 1929, his mother told them that they could not live with her. The couple decided to move to Snoqualmie Falls, Washington, where Leif studied to become a police officer. He had taken the test and was ready to start working when his mother wrote to say that she had changed her mind. Leif could have the farm, and she would move to Kalispell. "So we did that," said Eva. "There wasn't any of that 'do I want to do it.' You just did it. I don't remember what we paid for it, but it was the going rate. It seems like we paid her ten dollars an acre. It was a half section."

Connie was the infant during this move, and like the generation before them, the Amundsons started farming together at the start of a cycle of hardship. It was 1930. The Great Depression hit with the crash of the stock market in October 1929, and the Dust Bowl was just beginning. For years, settlers across the Great Plains had plowed up the prairie grasses and laid the land bare by overgrazing and farming. As an unprecedented drought grew, there was nothing to prevent the soil from simply blowing away. Eva remembered wetting towels and hanging them on windows just to help her family breathe. "The towels would get thick with mud, but you had to do it," she said. "A lot of babies died of dust pneumonia. I can remember the old Russian thistles that would build up on the fences and the sand that would collect." The conditions would prompt Congress to establish the Soil Conservation Service in 1935 and the Montana legislature to establish conservation districts in 1939. Liberty County Conservation District, where the Amundson farm was located, is one of fifty-eight districts created by Montana in 1939.

Hundreds of thousands of families lost their farms and ranches during the 1930s. The Amundsons were not one of them. Unlike Eva's father, Leif knew the land and how to work it. "We had milk cows, a few pigs and a big garden. We had plenty to eat," said Eva. "But unless you lived through that, you can't imagine how bad it was. People had mortgaged their places until

their payments were sky high, so they lost them. They just pulled up stakes and left. It was kind of survival of the fittest. We lasted because we stayed."

Born in 1930, Connie didn't have any memories of the Dust Bowl specifically, but she believed it was a time when her parents' perseverance came through for them. "It's a little rough to say, but some people just didn't have enough gumption to stay during the hard years; it was easier to move," said Connie. "But we stayed. Like Mother said, you just do it, and that's all there was to it."

In addition to being tenacious, both Eva and Leif were progressive thinkers. "My husband was an unusual person," said Eva. "When I think back, I think, gee, he was a smart man." In Connie's mind, it wasn't just her father. Her mother was just as intelligent. "They were both very forward-thinking. They talked everything out and supported each other." Over time, the Amundsons would be the first in their area to buy a tractor, put in a

JOYCE LARSEN DYE
TOOLE COUNTY CONSERVATION DISTRICT

Although Joyce Dye and her husband, Henry, raised their family in Shelby, Joyce has many fond memories of growing up on her parents' farm east of town.

"Dad fixed up twenty-two-volt electricity for the house, but we had to be very careful and not use too much because if the wind didn't blow, we didn't have electricity. We would listen to the radio news at noon and in the evening, and then we always got to listen to *The Lone Ranger*. My brother, Quinten, got me started on the trumpet, and my sister, Alvina, helped me learn to read music and I played piano some. In the spring, all of the small-town bands went to Havre where they closed off the streets, and we all played. We had uniforms. Purple and gold were our colors. Quinten worked on the combine and tractor, but he had started with the band and would come practice with us. Every night, we sat in the kitchen and played songs from the books that we had for our band concerts. Sometimes Dad would get his guitar out and play with us, and sometimes even Mother would get her mandolin out and play a bit with us."

propane refrigerator, have running water in the house, get crop insurance and do strip farming to prevent soil erosion. Leif also wired the house for 32-volt electricity so Eva could have an electric washing machine when all of their neighbors were content to wait until 110 was available. "A lot of people laughed at him and told him, you can't do this, you can't do that. Well, of course you can do it. He knew how, or he'd figure it out," said Eva.

Leif also believed that women were as smart as men and sought Eva's opinion in everything—although there was that one day when he came in and said, "You better sit down, Eva." Turns out he bought another 320 acres at a sale he happened upon. After she got over the shock, Eva saw the reasoning behind it: "We always planned ahead a little bit. We'd had a real good crop of wheat that year, and there was something where you could only sell so much and then you had to sell the rest for fifty cents a bushel, government stuff, you know. So we had sold what we could [at market rate] and put the rest in the granary. Everybody at the sale that day told him he was crazy, but he said, 'I have the wheat to pay for it.' By then that fifty-cent thing had been lifted. Well, that first year he seeded that new half section

The Amundson family (*from left to right*): Eva, Priscilla, Connie, Eleanor, Leif and Ardis (*center front*), 1944. *Courtesy of the Amundson family.*

44

and got back what he paid for it. So we thought about the future, you know. That's what you had to do to make a go of it."

During the early years when her parents were constantly working, Connie remembered playing with the cats and cattle because there were no other children around. It would be five years before her sister Eleanor was born, and perhaps that influenced the independent person Connie would become. "Independent or stubborn," laughed Connie. "The biggest fight my husband and I ever had was when we'd probably been married just a few weeks. He told me I had to do something, and I told him, 'No, I do not have to do that.' Whew, it's funny that we didn't get divorced then and there. But I'm independent. It's just my nature."

One of Connie's strongest memories as a child was the hailstorm of 1935. The family had gone on a church picnic to the Sweet Grass Hills and didn't know about the damage until they returned home. "I was five years old, and I can still see it," said Connie. "We came over the hill, and where there had been fields, there was nothing. Everything was brown like it was fallow. We stopped at a neighbors, and the bucket they had on their porch was full of ice." Only that morning, Leif had come in from the fields and told Eva how beautiful and bountiful the crop was. "He said forty or fifty bushels….Then [the storm hit] and you couldn't even tell it was seeded. That was a shocker," said Eva.

Once again, the Amundsons made do. With eight milk cows, they could have sold cream, but Eve churned butter when Connie and newborn Eleanor were napping and sold that for coffee and other extras. "We had our chickens and things, so we didn't suffer as far as food was concerned. Leif always said that the best insurance you can have is good food, and we never skimped on what we wanted to eat. We didn't go hog wild but we always had good, good food." Including, she added, canned goods. Eva would usually can around two hundred quarts of fruit and about the same of meat every year.

In addition to Connie and Eleanor, Eva and Leif would have two more daughters, Ardis and Priscilla. Born in 1938, Ardis contracted polio and whooping cough as a baby, leaving her with physical disabilities that included speech impairment from brain damage. Eva read as much as she could to learn what treatment was available. Some of her research took the family to Michigan, and although the doctor there couldn't help Ardis, he told them about a retired speech therapist from the University of Montana in Missoula who was working with children with disabilities. Never ones to do anything halfway, the Amundsons decided to move to Missoula in 1948. Just as many ranching women moved with their children to town during the

winter, Eva and her daughters lived in Missoula during the school year while Leif commuted as necessary to keep the farm running. In the summer, they all went back to Joplin.

The move was transformative for both Eva and Ardis, who was one of the first five students of the Opportunity Resource School. Eva's volunteer work was instrumental in founding the organization, which was renamed Opportunity Resources Inc. (ORI) in 1955. Today, the nonprofit serves thousands of people with disabilities in western Montana through residential, employment and other programs. "People forget what it was like back then," said Eva, describing the pressure on families to institutionalize their children with disabilities. "People would say, you can't teach those children, and I'd look at them and say, 'Well, I think we can.' I guess I didn't realize how much push I had. But when people would say, 'You can't do that, Eva,' I'd say, 'Sure you can. All you do is a little bit at a time and it gets done.'"

In the early days, the parents would do whatever they could to raise money and awareness of the organization, even selling candles on the corner of Higgins Avenue and Main Street. Eva spent more than sixty years volunteering for ORI and continued to sit on the board of directors as an emeritus member until her death. Her leadership and willingness to give of her time garnered extensive recognition and awards. In 1998, the City of Missoula proclaimed April 22 as "Eva Amundson Volunteer Day," and ORI honors a volunteer family with the Eva Amundson Award each year.

While her mother was helping build ORI, Connie made her way to cattle ranching. She was eighteen when the family moved to Missoula, and at Eva's insistence, Connie started attending the University of Montana and lived on campus. She lasted two quarters. "I was so proficient in shorthand and typing that there weren't any other courses I could take except English and history and things like that. I didn't want to do that so I quit and went to work," she said. Connie started at the National Park Service and then went to work for the Bureau of Indian Affairs, which required a move to Billings. There she met Don Cain, a rancher from Stacey. "It wasn't a lightning strike sort of thing, but we just clicked," she said. Despite that first clash of wills, the two were married for sixty-one years before Don's death and raised two children, Marlene and Mark, on the Cain family ranch. Connie quickly took to the life. "I don't know if we ever talked about a love for the land; it was just always taken for granted," Connie said. Don and his father worked the ranch together until his father died in 1974. "Then Don ran the ranch by himself," said Connie. "I did

GEORGIA TOVATTEN TOMSHECK
GLACIER COUNTY CONSERVATION DISTRICT

Georgia Tomsheck and her husband, Ray, raised four children on their farm.

"Life on the farm has been wonderful to me and my family. I can't think of a better way to raise your kids. It's hard work and teaches everyone to work together. Every year when harvest was over, it was AMEN! Yes, I would do it all over again."

whatever was necessary. If I had to be out in the field driving tractor, I was in the field. If I had to drive to town and get parts, I'd drive to town. Whatever had to be done, I did it."

Connie was a longtime member of Women Involved in Farm Economics (WIFE) and served as the organization's state treasurer for twenty-four years. She had strong opinions about politics and the business of agriculture. "Personally, I hate politicians," she said. "I think they are a bunch of jackasses. I don't think most of them had a piece of dirt on their hands in all their lives." As a cattle rancher, she kept up on the issues even after retiring to an apartment in Broadus. "It's a different world now. Like Mother says, they didn't even have crop insurance before, but now ranchers have to worry about estate planning." After Leif died, Eva decided to lease the family farm and eventually turned over the management of the Joplin land to Connie. For her part, Connie and her children formed a partnership after Don's death to manage their share of the Cain ranch. Connie hoped that all the farm and ranch land would stay in the family.

Eva let go of farm life after Leif's passing. "I don't miss the land. My husband and I had a good thing together and I miss that, but I've been by myself for so many years that it's another life," she said, just a few weeks before her death. She was very active in numerous organizations in Missoula besides ORI, including the Missoula County Senior Center. She served as president for three years, and her humor and leadership skills were once again in evidence. "I'd suggested in a meeting once that we should get a computer, and later somebody came up to me and said, 'Did you hear about

that? What nut would suggest something like that?' And I said, 'You're looking at her,'" Eva laughed.

Maybe more than anything else, it was Eva's love of learning that kept propelling her forward, doing what others might walk away from. It never left her. "When you get to be over one hundred, you kind of let things slide, but I still have that urge to learn," she admitted. "But like I told somebody the other day, I've accomplished maybe what I set out to do, which was to help people. That's been my big project in my life. And I am a good friend."

"When You're a Farmer or Rancher, Your Kids Are Involved from Day One"

Valerie Miller Wadman

GLACIER COUNTY CONSERVATION DISTRICT

Several years ago, Valerie Wadman got a call from a couple who wanted to come and help out on her ranch for a few weeks. She wasn't enthusiastic. They were responding to a post she'd put on an internship website, but Valerie's first experience with an intern had been a bust, and she had little interest in trying it again. Luckily, the couple was pushy. "They had just finished working at Glacier Park and were at my door before I had time to tell them no," said Valerie, who owns the Bar VW Ranch, located just outside of Cut Bank. "So I asked if they had any experience herding sheep, and the young man said, 'No, but I've chased monkeys around the jungle.'" That worked—so well, in fact, that Valerie has hosted several interns a year ever since.

Valerie originally turned to the internship program as a way to get short-term help after her youngest child left home and she was running the ranch on her own. Over time, she found that she enjoyed sharing her knowledge and lifestyle. Interns come from all across the United States, as well as other countries. Some are out for an adventure, others just need a break from their lives and many are young people who hope to have land of their own someday to raise animals and produce their own food. Whatever their intent, Valerie finds purpose in mentoring them: "I've had people here who have never seen an animal being born. They may never have had an animal die. Some even freak out when they crack an egg and find two yolks. But I've always figured that even if they aren't going to ever live on a farm or a ranch,

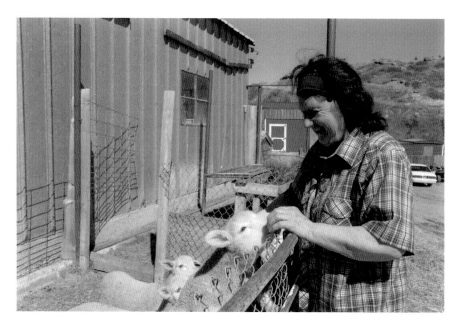

Valerie Wadman is greeted by her "bums," lambs that need to be bottle-fed because their mothers have died or can't nurse them, 2017. *Courtesy of Ross Campbell, DNRC.*

they will gain life skills and knowledge, as well as a better appreciation for what farmers and ranchers go through to provide them with food. So I think being willing to be a mentor for them is really important."

Valerie feels a deep kinship to those who want to connect to the land. She grew up in town, always wishing she were living on a farm or ranch. Fortunately, she was able to visit her relatives for a taste of the life she wanted for herself. It is becoming much harder for those without family access. "The last figure I heard was that less than 2 percent of the U.S. population is in agriculture now. So when young people want to learn what it takes to run a farm or ranch, many have to search for the opportunity," she said. Valerie remembers the challenges she faced in her twenties when trying to learn about agriculture. "Fortunately, I had some good contacts. So in the spirit of my mentors, sharing with my interns has become a way for me to pay it forward. I understand that the internship program isn't for everyone. Hosting and interning is a leap of faith on both sides. But in my experience, the rewards outweigh the challenges."

Valerie realized her dream of living on the land when she married in August 1970 and moved to the Bar VW Ranch. It was initially a country home, as both Valerie and her husband taught school. Valerie has a degree

in home economics with emphases in early childhood development and nutrition, and although she wasn't trained as a teacher, she was able to sign a three-year teaching contract with the Oilmont Elementary School under a federal program designed to support rural schools. When her contract expired in 1973, she began to look for ways to use the ranch to contribute to the family income. "It was important to me that I be here on the ranch with my kids, and I wanted to replicate the life I'd seen on my relatives' farms."

In building that life for her children, Valerie started with a dozen chickens, two goats and a single milk cow that she bought from a neighbor. "He told me that I could take the cow home after I learned how to milk her, so I went over there every day for about a month until he was satisfied that I could do a good job," she said. In time, Valerie added a couple more milk cows, along with some beef cows and a few pigs. Income from the milk and eggs was enough to cover the feed for the livestock and some groceries, while the sales of calves and pigs covered other ranch expenses. At the same time, her

JUDITH BLACK KNAPP
TREASURE COUNTY CONSERVATION DISTRICT

Judi Knapp and her husband took up ranching in far-eastern Musselshell County in 1976. Judi also worked for a rural electric co-op for many years, spending the week in town and returning home on weekends. She now serves as a supervisor for Treasure County Conservation District.

"Some of my fondest memories are the four-wheeler rides Roger and I would take each Friday evening when I would get up to the ranch from my town job. We always rode double and went first to check on the wheat, of course, to see how much it had grown in five days, and then to check on the wildflowers. Roger always knew which ones had popped open since I'd been up the weekend before. And then the wildlife. We see elk more frequently now, plus there's usually a coyote or a deer or turkey that shows up. I still love that feeling of checking things out together. My retirement gift was an ATV of my own, so now I find any excuse I can to jump on it and go, under the pretense of work, of course."

family was growing, with five children born between 1976 and 1987: Valora, Vanessa, Willow, Willie and Wyatt. "The ranch was a great place to raise them," she said. "When you are a farmer or rancher, your kids are involved from day one. They learn how to work and be responsible when they are very young."

Valerie has many favorite stories about that involvement: "We had a Shetland pony named Thunder that all the kids learned to ride on. One day the cows had crossed the creek and were just standing there looking at us. It was time to milk, so I put my oldest, Valora, on Thunder and told her to go bring them back. But our good little pony decided to pull a pony trick. Thunder went out a few feet and then laid down, getting Valora all wet. The water wasn't deep, but it was a little cold. I started to laugh, and Valora got madder at me than she was at the pony."

Valora wasn't the only child to have a run-in with livestock. Vanessa was about four and old enough to gather eggs when "one day I looked out the window and there she was hot footin' it down from the chicken house with the old rooster on her heels. The eggs were raining down—she'd tossed the egg bucket high in the air so she could run faster. It was quite a sight."

By the time the boys were old enough to help with the livestock, the sheep flock had grown to the point of requiring chute work. Willie's job was marking each sheep's head to show that it had been vaccinated, and one day he got a little creative. The sheep ended up sporting makeup, peace signs and other designs. All five children were very active in 4-H. Willow was the first to have a market lamb for a 4-H project and won a blue ribbon in showmanship and reserve champion in the carcass contest. Wyatt made the winner's circle in a cooking category despite, or because of, making the mistake of putting all of the cake batter into a single pan instead of dividing it in two. Because his entry was showing the difference between using sugar versus applesauce as a sweetener, he had to make the same mistake twice for a proper comparison. When the local newspaper picked up on it, Wyatt and his recipe were featured in the "Cook of the Week" column.

In addition to the food provided by the livestock, the family raised a big garden and canned, froze and stored produce in an old root cellar. Nearly all of the cooking was done from scratch, and homemade bread was a staple in the Wadman house, leading to another family story. Valerie bought wheat for bread in 50-pound bags and ground it in her Magic Mill. One day when company was coming, Vanessa was helping with the bread. As she poured the grain into the hopper, Valerie heard her gasp. "I turned to look, and here was this very dried-out dead mouse in the hopper.

Vanessa's eyes were as big as saucers, like 'what do we do now, Mom?'" Valerie was philosophical. "I said, 'Well, Vanessa, we've already eaten half of the grain that was in this bag and nobody has gotten sick or died. So we're just going to take out this mummified mouse and not say anything.' So that's what we did," Valerie laughed.

Despite the joy Valerie got from being with her children doing the work she loved, life knocked her down in the late 1980s. It started when she went into a debilitating depression from stresses stemming from her troubled marriage. "I didn't know what had happened to me," she said. "All I knew was that I couldn't do the things I used to be able to do." It helped when she happened upon a magazine article on depression. "I could check off almost every symptom that it listed. But it also said, 'you will come out of it,' and that gave me hope." Valerie pushed herself mentally and physically toward recovery, focusing on positive activities for herself and her children. On a trip to visit family in New Mexico, she stopped by the Dubois Sheep Experiment Station where breeds of livestock guardian dogs from other countries were being studied for use by sheep producers in the United States. She also attended ag workshops and ranch tours, and participated in the Montana Centennial Cattle Drive. Gradually, Valerie recovered. Then, in January 1989, the family had another devastating blow when Willow was diagnosed with Ewing's sarcoma. To help her little girl who loved to run and ride horses deal with hospitalizations, surgeries and, at one point, a body cast, Valerie drew on her experience with depression and focused on finding things Willow could do, even with her horse. Sadly, despite treatment and prayers, Willow died in May 1992.

Valerie and her husband divorced two years before their daughter's death. As she rebuilt her life as a single parent and rancher, Valerie considered her options. "I had given serious thought to moving to another place with some acreage, but there was no money to fund it. Also, my kids had been through so much it seemed best to dig in and try to make this place work." Times were lean. Valerie did what she had to, working part-time reading meters for Glacier Electric Co-op and standing in line at the food pantry. The kids did their share as well. One Christmas, when there was no money for presents, Valora used her earnings from McDonald's to buy ingredients for cookies so that the family had something to give to their relatives. "Learning how to handle tough times in a good way really can make one stronger in the long run," said Valerie.

Valerie had sold or leased out most of her livestock when she was unable to care for them. She got her cows back after Willow passed away and then

EVELYN ALLEN AIKEN
LIBERTY COUNTY CONSERVATION DISTRICT

Growing up in Whitlash, where her family owned the general store, Evelyn Allen learned ranching by working on and off for her future husband's grandmother, beginning with doing her housework one summer. Evelyn married Glenn Aiken after a fourteen-year engagement when his grandmother died in 1955.

"I got an education in housework the summer of '42 when I worked up there. Then, of course, they were drafting everybody and Glenn couldn't get anybody to help him, so it was decided, 'well Evelyn could help.' So then I started helping outside too. I did anything that needed doing. I'd work there in the summers, then go back home during the winters and help out there. In 1950, Glenn's grandmother had to have surgery, and they were gone for a whole month. I had never milked, but I had to milk the cows and carry the milk to the house and separate it. I got so I was doing everything. I worked 24/7, but as long as his grandmother was alive, he wouldn't marry me…. I think all ranchers are conservationists, because you don't leave the cows in a pasture until it is eaten down. You move 'em around. And you sometimes move water around. I've witched quite a bunch of wells, and I haven't missed one yet. We've got them in all of the pastures now. They have to be pumped, they're not artesian, but they all have had good water.

"Glenn and I didn't have children, so after he died I didn't know what I was going to do with the place. I'd known Toni for a long time; she used to buy milk and eggs from me. So I asked her one day, 'What do you think about me adopting you?' She said, 'Well, I adopted you a long time ago.' The day she was proclaimed my daughter, the attorney said, 'Well usually this is the time when they take pictures of me holding the baby, but I don't think I can do that.' Toni is taller than I am. She helps me all the time, and most of the time, she and her husband, Ron, won't let me go anywhere without one of them. She's a ranch wife too. She does everything."

had an opportunity to buy thirteen ewes, which became the foundation of the flock she has today. Her animals have always helped her keep going. "When you have livestock, you can't crawl under the bed and stay there just because you don't feel like getting out. No matter what, you have to care for them. And there has never been a day spent outside tending to the animals that hasn't left me feeling better. Tired, maybe, but refreshed," she said.

One of her joys of having livestock is watching them interact. During a drought one summer, she was able to pasture her sheep on a ranch north of her place for a month. As she unloaded the sheep at the corral, she could see and hear the coyotes everywhere. "I was so nervous that I stayed in the pickup that night to watch over them. But Bandy, my guard dog, knew his job. He would take off, and I could hear him barking way out there. Then he'd come back, check the sheep and away he'd go off in another direction." Bandy kept it up all night, and the coyotes got the message. "My intern sheepherder reported that the coyotes never bothered the sheep the whole time up there."

Valerie ran around one hundred ewes and their lambs for many years. At one point, she experimented with organic certification but didn't see a sufficient return on her investment. "I liked the approach but had to drop out of the program after three years," she said. "Adding in the costs of traveling halfway across Montana to get organic feed and straw, plus the costs of inspection, left no profit. I think to successfully go organic, you need to be closer to a market that supports organically raised livestock, and you need to have the ability and land to raise the feed needed." She now lists her lambs as grass-fattened and raised without inputs.

In addition to adding fencing for grazing rotation, one of Valerie's early steps for restoring her land was putting her cropland into the Conservation Reserve Program (CRP) in 1990. The federal program pays farmers to take marginal land out of production for ten years and manage it for specific conservation goals such as wildlife habitat and reduced soil erosion. After the contract was up, her CRP land became pasture for her livestock. Through another program, Valerie also was able to get cost-share construction of a boundary fence by putting aside a fifty-foot strip of land for wildlife habitat. Not everything she's tried has worked, but Valerie chalks up a lot of the setbacks to poor advice and not knowing better. She now has her own advice for others new to agriculture. For example, she suggests that whatever stocking rate is recommended to them, cut it in half, as there will be dry years. Also, Valerie says, reseed immediately after fiber optic cables are laid or oil drilling occurs to prevent weeds; don't rely

Valerie Wadman's goats look down on her ranch. Cut Bank Creek serves as the boundary between her ranch and the Blackfeet Reservation, 2017. *Courtesy of Ross Campbell, DNRC.*

on the companies to do it. And finally, know when to move stock off the pasture. "It took me many years to even begin to see how important all of this is, and now it will take me many more years of work to reclaim my land," she said.

Valerie looks to her ancestors for inspiration. Her maternal great-grandmother, Agnete Forseth, homesteaded in the Sweet Grass Hills after emigrating from Norway at age fifty-one with her four children. Valerie's paternal grandfather, Frank Miller Sr., was another role model. Frank was in the oil business in northern Montana, but his wife, Leola, wanted to live where there were trees. "So Grandpa bought a farm on Whidbey Island near Puget Sound," said Valerie. "After World War II started in 1941, the military took over the island, and all of the residents had to leave. We believe that Grandpa took the 'rent' money from the government and bought the ranch on the Marias River." A decade later, the government's right to eminent domain took that place as well when the Bureau of Reclamation started building Tiber Dam in 1952. Frank went to court to challenge the government's buyout offer but lost. "Dad said that one of the reasons the court didn't award Grandpa the true value of the ranch was that they didn't believe Grandpa could actually raise three cuttings of alfalfa hay in a season," said Valerie. Everything had to be auctioned off, including the ranch house, which was particularly hard for Frank, as he had moved a one-

room cabin from his oil lease to the ranch and then added to it to create a comfortable home. Frank lost the house to a higher bidder—but not for long. His neighbors refused to let the buyer move the house across their land. "So with the neighbors sticking together, Grandpa got his house back and moved it to Conrad," said Valerie.

Although Frank didn't own the Marias River ranch long, it became Valerie's touchstone when she and her parents and brother lived there for several months. Valerie was born in Seattle in 1947. Her parents, Frank Jr. and Grace Miller, had moved to the Whidbey Island farm following the war when the military let the residents back in. After Valerie's younger brother, Kirk, was born with hydrocephalus, they moved back to Great Falls to be closer to family, and it was then that Valerie first fell under the spell of life on a ranch. When her grandpa invited them to live with him for a while so that her dad could help with the sheep, she was six years old and in her element. "I had two baby cottontails that Grandpa had brought up from the field in a pen with a duckling that was won at a booth at the Marias Fair. I saw my first lamb born and I got to bottle-feed the bum lambs," she said. "It was beautiful there with all of the cottonwood trees, the fields of alfalfa and mustard blooming. I remember the hollyhocks outside the cabin and the geraniums inside, which might be why they are two of my favorite flowers and I have them planted on my ranch."

BONNIE HODGSKISS THIES
GLACIER COUNTY CONSERVATION DISTRICT

Bonnie Hodgskiss fell in love with sheep while growing up on her uncle's ranch near Choteau. She was finally able to have her own flock after she married, and she and her husband, Henry Thies, settled outside of Cut Bank.

"I always knew I would have sheep of my own some day. I loved growing up on the farm. It has always been a part of me, it happens that way. I'm what you might call a nighttime sheep rancher. I work for the NRCS [Natural Resources Conservation Service] during the day and attend to my sheep in the evenings. I wouldn't have it any other way."

Valerie Wadman and her dog, Duncan, ride out for their daily check on the sheep, 2017. *Courtesy Ross Campbell, DNCR.*

Decades later, Valerie has no doubts about her calling birthed in that summer of 1953: "When I started living on my ranch, it was the school of hard knocks and workshops. Even my relatives who are in agriculture thought I was kind of crazy. But if it's in you, it's in you. It isn't going to go away. That inner love for your land is the biggest asset you have if you are going to succeed in farming and ranching. It will give you the determination to make it work."

Looking ahead, Valerie's main goal is to improve the health of the Bar VW Ranch so it is viable at 275 acres to support small numbers of livestock. None of her children is in agriculture, but she would like the ranch to stay in the family. "Because once it is sold, it is gone." She loves seeing her grandchildren enjoy the lifestyle when they come and stay with her. "I see a lot of the same enthusiasm I had when I was a child when they are helping with chores, riding horses, exploring the creek or making things from the scrap piles that every honest ranch has," she said. "They seldom feel the need to get into the bag of toys they bring with them."

In the meantime, Valerie keeps busy. In addition to running her ranch, she is a local brand inspector and also conducts ag surveys for the USDA. She is gradually cutting back on her livestock numbers to free up time

to spend with her grandchildren as well as to pursue other ag-related interests such as spinning wool, making her own dyes and other wild crafting with plants in the area. She is also considering hosting workshops and redoing a campsite on the ranch to be used by bicyclists and youth groups. "The proximity to Cut Bank makes a lot of ideas possible, and it's my hope that the ranch will continue to make a contribution in some way, especially to young people," Valerie said. "Until then, I'll continue to do what I can with what I have. The work is good. The enjoyment of living here for over forty years is still there."

"I Took to It Like a Duck Does to Water"

Dorothy Whitten Hahn

Broadwater Conservation District

Now in her nineties, Dorothy Hahn's tiny frame and easy smile might cause a stranger to consider her a sweet but perhaps rather inconsequential little old lady. That would be a mistake. In her day, Dorothy raised three children, drove tractor, bucked eighty-pound bales, helped birth lambs and calves, butchered hundreds of chickens, volunteered in her community, partnered with her husband in all ranch decisions, cooked for a crew, moved cattle on horseback, canned until midnight and got up before dawn to do it all again. Or as she puts it, when Dorothy married into a Montana ranching family, "I took to it like a duck does to water."

Dorothy was born in Bussey, Iowa, to Swedish immigrants Marion and Mable Whitten. Her father worked as a railroad section foreman, getting just three shifts a week during the Depression, while her mother raised Dorothy and her six siblings. Life wasn't easy, but the family was close and Dorothy describes a happy and active childhood that included boxing matches with her older brothers when she "threw the punches so fast all they could do was laugh." Her need to be active honed her work ethic early on. She delivered newspapers as a teenager, babysat and cleaned and did ironing for the neighbors. After graduating from high school as class valedictorian, Dorothy went to work full time at the local grocery store. "There wasn't any money for me to go to college. I could have had a $100 scholarship to the business college, but I didn't want that. I wanted to be a nurse or a teacher. So I just

Dorothy Hahn, ninety-two, at her ranch southwest of Townsend, Montana, 2017. *Courtesy of Ross Campbell, DNRC.*

went to work at the store." She made $8 a week working from eight o'clock in the morning to ten at night.

Dorothy came to Montana in 1943 to visit an aunt who lived near Townsend. Soon after she arrived, she met local rancher Paul Hahn, and if it wasn't love at first sight, it came soon enough. When the two were married in August 1944, Dorothy moved to the 1,110-acre sheep operation that Paul ran with his mother, which was located along the Missouri River in Broadwater County. Dorothy was just nineteen, Paul, forty-five. The twenty-six-year age difference was never an issue. "You wouldn't have known it. All his life, he was just like a young man. And wiry, he never weighed 125 pounds," said Dorothy. Paul took over most of the ranch work when he was twelve after his father was killed by lightning. "He only went to the eighth grade, but boy, I tell you, that guy could do anything. And he was always good. He never swore, and he had patience galore." Paul was just as impressed with his wife, often telling her that "they broke the mold when they made you." The two worked as a team from the start. Should a buyer come to look at the calves or lambs, Paul would tell them he had to consult with his wife before making the deal. Any disparaging comments were silenced by his affirmation that Dorothy and he "were in this together."

BARBARA BEERS KIRSCHER
BROADWATER CONSERVATION DISTRICT

Raised in Judith Gap, Barbara Beers Kirscher moved to the Townsend area after she and her husband graduated from college. The couple lived on the Kirscher homestead, part of which was flooded by construction of Canyon Ferry Dam in the mid-1950s. Barbara passed away in May 2016.

"My husband's family had been pioneers and had been here since the 1890s. His grandfather Joseph Kirscher had run a stagecoach and a freight business from Virginia City to Fort Benton. Then one winter was so severe that he almost died. An egg cost ten dollars, if you can imagine, and flour was so scarce that it cost a gold nugget for a pound. His brother, Peter, gave all of his food rations to him because he was so ill, and he pulled out of it. His brother had land here, but he decided to go to the Shields River country and sold it to him, and then Joe also bought land that belonged to a neighbor. And that's 550 acres that are under the lake now. In those days, the land that is now under the lake was all what we called sub-irrigated. There was no irrigation on top. There was enough moisture that they could grow 30 tons to the acre of beets, and anybody who knows sugar beets knows that was terrific without irrigation. When we came, we had what we called the upper ranch, which is along Ray Creek Road now. We had mostly just hay and grain and sugar beets. Then we worked into cattle as the sugar beet industry went out. At that time, it was irrigated by shovel irrigation. Now the land is all under pivots."

The Hahns faced their biggest hardship just a few years after their marriage when the Bureau of Reclamation, Montana Water Board and Montana Power Company moved forward with their plan to replace the original Canyon Ferry Dam constructed in the late 1890s. The new dam and power plant would be located 27 miles downstream from Townsend and create a reservoir covering 33,500 surface acres with 96 miles of shoreline. Among the prehistoric Indian campsites, mining camps and dozens of

productive ranches slotted for submersion was the Hahn place. "It was terrible, terrible," said Dorothy. One of the many traumatic aspects of the loss was the uncertainty of the timing. "They kept saying that they were going to take the land in 1948. We had over a thousand head of sheep. We didn't know where we were going to go, and we didn't want to reseed any of the land if they were going to take it. Well, then they didn't do it until 1952, but we'd sold the sheep to Paul's brother in 1948."

Unfortunately, living in limbo without an income wasn't the worst of the experience for the Hahns. When the government negotiator and appraisers finally arrived in 1952, they offered the family just $12,000 for the ranch despite a $200,000 appraisal value. "We wouldn't take it," Dorothy said. "We knew what our place was worth. We had a thousand-inch water right out of the Missouri River and a stream that went through our place that never froze so we didn't have to chop ice for the cattle. That stream was deep enough to take a canoe and had seventeen-pound trout in it." The ranch was ultimately condemned, and the Hahns ended up in federal court in Helena in 1954. Due to a "really bum jury," as Dorothy describes it—"we had a logger, a bartender and a chef on it, people who didn't know anything

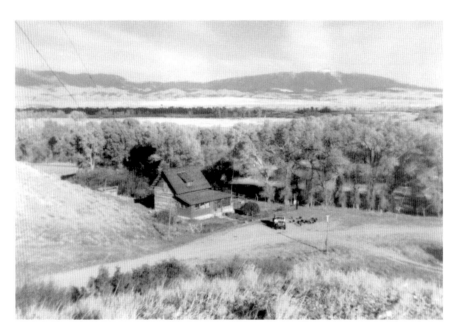

Pictured here in 1951, the one-thousand-plus-acre original Hahn Ranch was submerged when Canyon Ferry Dam was built. *Courtesy of the Hahn family.*

about it"—the Hahns were awarded only $82,000. After paying their lawyer, Dorothy said they ended up with $62,000.

The dam project still rankles many in the Townsend community, Dorothy included. "Thirty-seven ranches gone. It was terrible. That was the best land in Broadwater County—real black soil. There were so many trees that went along the river and all those leaves built up. Paul worked up one piece of that ground and put it into oats, and it made one hundred bushel to the acre." The loss of the ranch was particularly hard on Paul, who had lived there for more than forty years. "He even cried when we had our trial," said Dorothy. "You know, they just took it away. We figured we'd raise our kids there on that ideal spot. There was hunting and fishing, and we could make a good living for them. Paul always said that instead of building that big lake, they could have gone up here at Toston and started and built little dams all the way down, and they would have had the power and saved all those ranches."

While they waited for the trial, Paul and Dorothy borrowed money to buy a 347-acre ranch southwest of Townsend, where Dorothy still lives today. The new ranch would provide a good life for the family, but it was a difficult transition. Unlike the secluded privacy of the old place, the new ranch runs along the railroad right of way and Highway 287. And at just one-third the size, the initial acreage wasn't enough land to allow the Hahns to run as many sheep or cattle as in the past. They rebuilt over time. With the purchase of 700 acres near Winston, as well as grazing leases, the family now has access to about 20,000 acres for cattle, grain and hay production.

The Hahns have always considered themselves stewards of both their land and their animals. Irrigation efficiencies, minimum tillage and cover crops are just some of the conservation practices they have implemented over the years. In recognition of the Hahns' efforts, the ranch received the 2018 Environmental Stewardship Award from the Montana Stockgrowers Association. In particular, the organization noted the Hahns' enrollment in 1998 of 1,680 acres in Broadwater County's first conservation easement with Montana Fish, Wildlife and Parks (FWP) to keep the land in agriculture production and protect it from development. They have also worked with FWP, Broadwater Conservation District and others on a cooperative effort to restore Deep Creek, which provides the ranch with irrigation and stock water and is also a critical waterway for brown trout.

Dorothy worries about producers who don't do enough to keep the weeds at bay, as well as those who run too many cattle for the amount of grass they have. "You've got to feed them some supplements sometimes. We do that. And make sure you are feeding them enough hay, you know, especially when

Dorothy Hahn and her team of horses, Dolly and Joe, would buck up hay from the field and move it to the basket on the beaverslide, 1949. *Courtesy of the Hahn family.*

they calve. I think it's better that we calve a little later now, because we are closer to grass. I think people who calve in January, February, that's pretty tough because you get bad weather and then it takes a lot more hay." An even bigger concern for her is the loss of agricultural land to area subdivisions and a growing populace that doesn't understand the important role of agriculture. She believes that ag people need to reach out and teach others about their lifestyle to help close this gap. One way the Hahns have done that is to hire local teens to help change irrigation pipe and do other jobs during the summers. They've also opened the ranch to tours of kindergarten and first and second grade students. "We did that for years," said Dorothy. "The children got to try milking the cows and see how the sheep were sheared. And they got to feed a lamb on a bottle."

Those lambs hold a special place in Dorothy's heart. "I liked all of ranching, but I really liked lambing. Paul would check the cows, and I'd check the sheep. I'd think, I can get those lambs in and then get back to the house, but then there would be some trouble and I'd have to help get a leg straightened out so they could deliver or something," she said. Dorothy was also adept at processing chickens. At the original Hahn ranch, she raised 500 fryer chickens a year, most of which ended up at the Montana

Margaret Sanderson Floersinger
PONDERA COUNTY CONSERVATION DISTRICT

Born on the Isle of Man in the British Isles, Margaret Sanderson met Tom Floersinger during World War II when he was in the U.S. Air Force and stationed in England. The couple married in 1949 and moved to his family's farm in Montana. They eventually purchased a place of their own, where they raised their three children and lived for more than sixty years.

"There were times when I didn't enjoy it as much as I would have if I could have gone off to a concert or something, but most of the time I had the children and I wanted them to have the opportunity to live on the farm. It's a wonderful life. The young people need the land. I hope it never comes to the point where all the small farms disintegrate into the big ones. I don't like that....I did a good job of adjusting I think. One time, I was out on the tractor helping my husband, and when I went back to the house to start my evening meal, the phone rang. It was my mother calling from England. She said, 'Where have you been?' and I said, 'Well, I was out on the tractor all afternoon.' She was so surprised, she said, 'I didn't raise you to work in a field.' I always laughed about that. It wasn't such a bad thing, you know."

Club in Helena for catered parties and picnics. "Paul and I would kill 125 in a day. Our well was spring water, and we had a porch around two sides of the house. It was nice and cool, and so we'd fill tubs with ice-cold water and put the chickens in that. Then the next morning, we'd do 75 more and take 'em all into Helena." With the move, she cut back to raising just 100 fryers. She and Paul continued to share butchering duties, getting help from their three children as they got older, but Dorothy always set the pace: "I could dunk eight in the water and pick them in fifteen minutes. You get the water just the right temperature, and boy, you just took ahold of a leg and off comes the feathers." Dorothy raised fryers until the early 2000s. She also had 100 laying hens and delivered eggs house-to-house every Friday night for forty years.

Though she worked hard, Dorothy points out that most women in agriculture do the same thing, they just don't get the recognition. "I don't think people believe all the stuff women do," she said. "There are some that never work in the field, but most agricultural women have to help out some way or another. I did everything, even ran a little D2 Cat. I also buck-raked the hay up to the stack and then put it on the stacker, and then I pulled it to Paul. He moved every forkful of that hay because he wanted to know when wintertime came where he was going to start taking it out. He made a neat stack."

The Hahns had creative ways to tend to their children while attending to the ranch. After their daughter, Beverly, was born, Paul attached a box equipped with a tiny steering wheel to the tractor so that the toddler could help her mother "drive." And when their first son, Chuck, came along, the Hahns pulled a sheep wagon into the field so that the children could nap and play with their toys while their parents worked. "They were the best kids," Dorothy said. "I always worked in the fields. After Bev turned eleven, she took care of John, our youngest, and she would cook the meal. Boy, I'll tell you, those kids did everything. Chuck was raking hay with a tractor when he was nine years old."

Paul passed away in 1984. Although Dorothy continued to work outside for many more years, she gradually turned over the management of

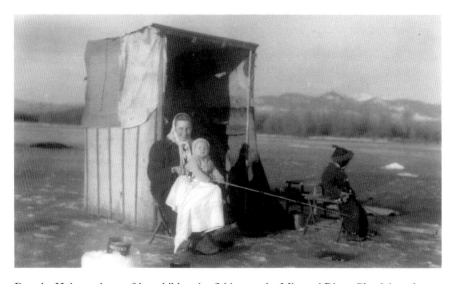

Dorothy Hahn and two of her children ice fishing on the Missouri River. Chuck is on her lap, and Beverly is fishing, 1949. *Courtesy of the Hahn family.*

HELEN GREUTMAN CAREY
JEFFERSON VALLEY CONSERVATION DISTRICT

Helen Carey was the first woman to be named Conservationist of the Year by the Jefferson Valley Conservation District. Among the improvements she and her husband, Tom, have implemented on their cattle ranch in the Boulder Valley is a five-year program to set aside areas for wildlife with the help of the Environmental Quality Incentives Program (EQIP).

"The goal was to set aside thirty feet on each side of the river to provide wildlife cover and forage. Now we've got good windbreaks on both sides to help with cover, and we've got wells and water tanks out here so the cattle don't water in the river. At the feedlot that was too close to the river, they were able to put in a culvert and berms so the dirty water goes out and fertilizes the field. Another thing that we do now is, when we start to hay, we go into the middle and cut out. That allows wildlife cover to move out ahead of us. If you hay from out to in, they can only move in, and then you are liable to wipe out birds or deer or anything nesting."

the ranch to Chuck and John, who in turn brought in two of Dorothy's three grandsons. The men added a trucking business in the 1990s for an additional revenue stream and now haul grain, hay and other products. These days, Dorothy continues to cook for whomever is around for the midday meal, but her activities are primarily community-focused. She continues to visit three nursing homes on a weekly basis, something she has done for more than thirty years. She also continues to donate baked goods for local fundraisers, such as the silent auction during high school homecoming. Dorothy is known particularly for her pies. In fact, she has gone so far as to testify in front of the Montana legislature on behalf of those pies when legislation was proposed years ago regarding the sale of home-baked items. She had no patience for those who brought up the question of proper hygiene. Dorothy recalled: "I went with three other gals to Helena. I told the committee that we should be able to sell pies we make at home because I'd never been sick from a potluck but I have from eating

at a restaurant. A lot of those restaurants, the waitress comes out and brings the food, and on the way back she picks up those dirty dishes, which she should never do, and takes them into the kitchen. She doesn't have time to wash her hands. She goes right out there and picks up another dirty dish, and then takes the money. The money is the dirtiest thing there is."

She apparently made a persuasive argument. "By golly they passed it, and the governor signed it," she said, adding, "One legislator asked me if I brought a pie."

Government regulations are a concern for Dorothy when she considers the challenges her grandsons will face taking the ranch forward. She also worries about what it costs a rancher to make a profit. "You know, people don't realize what little you get from selling livestock and grain and all of the expenses you have," she said. "A long time ago, you'd get nine cents a pound for the lambs, and prices still aren't right for what you have. And the expenses—nowadays a tractor costs a fortune, a combine costs a fortune, and if you break down, those guys charge a lot of money for labor. It used to be that you fixed your own stuff and it was real simple, but they are computerized now, so you can't work on them. The seed costs a lot of money too, and then you gotta do some spraying and that costs. We even have an airplane do some."

Still, Dorothy doesn't tend to dwell on what she can't control or past hardships. She credits her long and healthy life to cooking her own food, being active both physically and in her community and having a positive attitude. "You might as well go on with your life and do the best you can," she said. She's always wanted to get up in the morning and get going, and that hasn't changed over nine decades and counting. "I like to keep busy. It's just one of those things." As to her legacy, Dorothy hopes that her grandchildren will be able to follow in her footsteps. "I'd just like to see them continue to be ranchers and take good care of the land," she said. "And make a pie once in awhile."

"You Don't Ranch Just Because You Love It—It Has to Be Workable"

Glenna Krueger Stucky

NORTH POWELL CONSERVATION DISTRICT

Glenna Stucky isn't exaggerating when she says that she wouldn't trade places with anyone in the world. Glenna lives on a ten-thousand-acre cattle ranch in Powell County surrounded by everything she loves—from her family and friends to the land and the lifestyle. "There is never a day that goes by that I am not in awe about being able to be here," she said. "I am so very thankful."

Located north of Avon, the ranch straddles Nevada Creek, bordering Highway 141 on the west and U.S. Forest Service land on the east. It is ideal cattle country, with native grassland and high mountain meadows that have supported generations of ranchers ever since Michael and Catherine Keiley moved to the land in 1872. Remnants of their past abound. Every time someone turns on the tap, water flows from the same spring a mile up the draw that quenched the thirsts of the Keileys and their eight children. Over a century later, their barns and outbuildings continue to shelter animals and equipment, while the thick walls of the main ranch house are reminders of the hand-hewn logs that kept them safe and warm. These ties to the past are both comforting and inspiring for Glenna, who looks to future generations to continue the ranching heritage. "I hope some of our family will always be here keeping this place as a living, breathing operation," she said.

The Stuckys moved to the ranch in 1976 from the Gallatin Valley. Glenna grew up on a farm outside of Bozeman with her two younger sisters, Marilyn and Lenita, and their parents, Ruby and Leonard

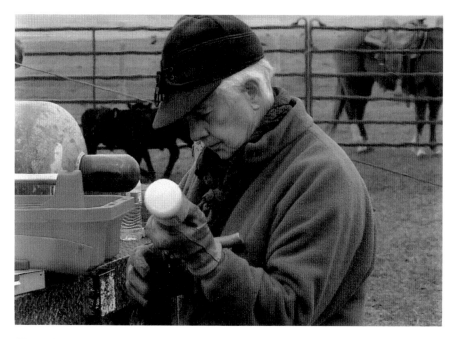

Glenna Stucky prepares vaccines to inoculate calves during branding, 2015. *Courtesy of the Stucky family.*

Kruegar. Ruby's parents also farmed close by, and Glenna has fond memories of the families working side-by-side. "It was a happy time," she said. "We would go and work at my grandparents' and then at my dad's, so it was a good arrangement."

After Glenna married Earl Stucky in November 1954, the couple purchased his family's ranch near Gallatin Gateway. They spent the next several years building their cattle business and raising their children, which then included Earline, Sharon, Calvin and Jill. Their lives changed significantly in 1966, when Earl was offered the job as cowboss on the Flying D Ranch. Now part of Turner Enterprises and then owned by the Irvine Company, the Flying D covers 170 square miles over two counties, with the Gallatin River on one side and the Madison River on the other. "It was a good opportunity for us," said Glenna. The Stuckys decided to move from the Gallatin Valley to Cherry Creek on the Madison to be close to Earl's work but still keep the family ranch. Although Earl's new position often kept him at cow camp during the week, with the help of their kids and a "good friend/hired man," he and Glenna were able to continue to maintain their Gallatin ranch and keep growing their own herd.

BARBARA BROBERG

GLACIER COUNTY CONSERVATION DISTRICT

Barbara Broberg became a farmer by following her husband's dream and making it her own. She was an active member of Women Involved in Farm Economics for many years and now serves as a board member of the Glacier County Conservation District.

"I love to hear the stories of others and their lives. It's the connection between the land, other farmers and the whole world. You become a part of a larger economic network—amazing!"

Ten years later, life took another big turn for the Stuckys. Earl and the manager of the Flying D were in the Avon Valley to buy some cattle that were pastured on the Keiley Ranch, which was owned then by Michael and Catherine's great-grandson. Ted Keiley and his wife, Ann, were getting on in years and were looking for someone who would take over the ranch work while still allowing them to live on site for a while. Deciding that it was the right opportunity at the right time, the Stuckys once again relocated their family, which now included their youngest child, Becky. This time they sold the Gallatin ranch and moved their cattle and equipment as well. "It wasn't a hard decision," said Glenna. "We were so fortunate to be able to lease it for several years and eventually buy it."

Life on the Stucky Ranch is all about the cows. Although they have herd bulls, they also rely on artificial insemination to provide desirable traits in their cow herd. Non-ag people might be surprised at the complexity of it all. Semen selection is based on the bull's EPD, or expected progeny difference, which is a prediction of how each offspring will perform relative to others in its category. Body size, age at puberty, climate adaptability, ability to fatten and retain fat, muscling and cutability are just some of the characteristics ranchers consider when planning for their next year's calves. "Catalogs list the EPDs for the different sires, so we choose by what we think is important," Glenna explained. "We want our calves to feed out as well as possible when they go on to the feedlots after they're sold so we look for those types of characteristics." Glenna keeps track of it all as part of managing the bookkeeping for the operation. "You have to run the

ranch as a business, which means you need to know costs and income and how it is going to pencil out," she said. "You don't ranch just because you love it—it has to be workable."

Insemination is timed so calving is typically done in February and March. Glenna is hands-on before and after calving, whether it is feeding heifers in the field or taking her turn at checking those who are close to calving. For many ranchers, calving is one of the most satisfying, if tiring, times of the year. But it also can be challenging, as Glenna's run-in with a hostile new mom a few years ago shows. "This one heifer had just calved, and I was going to iodine the calf's navel. She just backed off and then barreled at me, knocking me down. It knocked me out, and as I came to, she came at me again, trampling all over me. I was down flat and couldn't do anything until she finally backed off to where her calf was." Glenna managed to get herself up and had started for the barn when her daughter Earline came out to check on why Glenna had been gone so long. An immediate trip to the emergency room for a CT scan and stitches revealed that Glenna didn't have a concussion, but being stomped on resulted in a total knee replacement surgery a year later.

In addition to her calving chores, Glenna also looks forward to haying season, which starts around the third week of July, when the family builds large stacks of loose native grass in several different meadows to feed their cattle throughout the winter. In addition to cooking for the haying crew, Glenna has worked in the hay fields for many years. "I started when I was five years old, leading the stacker horse who pulled the loads of hay up the overshot stacker and dumped it onto the haystack," she said. Commonly used until the 1950s, an overshot stacker consisted of forks mounted on the end of two long arms attached to a pulley and cable system. When the horse pulled on the cable system, the hay on the forks was raised and dumped. These days, the Stuckys use a beaverslide stacker, which takes its name from Beaverhead County, having been invented in the early 1900s by two Montana ranchers in the Big Hole Valley. The beaverslide consists of a frame that supports a steeply inclined ramp with a basket. Hay is loaded onto the basket and drawn up the ramp by a cable system powered by a winch truck. At the top of the ramp, the hay falls onto the growing haystack. To get the hay to the beaverslide, the family uses a power buck rake—another piece of equipment that Glenna is adept at using.

As much as she loves her life, Glenna doesn't gloss over the more difficult times. "Our life shouldn't be romanticized," she said. "There are some days that are just darned hard but never to the point that I would want to

MARY LEE PINOD JACOBSEN
GLACIER COUNTY CONSERVATION DISTRICT

The morning after graduating from nurse training in Seattle, Mary Lee Pinod moved to Montana to care for her grandmother in Conrad. A few years later, in November 1953, Lee married Henry Jacobson and began an innovative ranching partnership that continues more than sixty years later.

"We lived nine years on the home ranch, then my husband and I bought our first irrigated farm and ranch just outside of Cut Bank. The first year, we hired an artificial inseminator to inseminate our cattle because we wanted to bring better genetic traits into our herd. Then we decided to go to school and become licensed ourselves. I was the first woman licensed inseminator in Montana. We taught it for about ten years. We had schools at our home ranch and various places to teach this new technology. People didn't really like it at first, but I told them if they didn't change their ways and start selling six-hundred-pound calves instead of six-hundred-pound yearlings, they weren't going to be in business in five years. We also had the very first exotics in the United States on our farm. We used Simmental semen from Switzerland as well as that from ten other breeds from Europe and showed people the difference—you know, don't be afraid. There are better things, and you have to use all these new tools. This was one of the reasons why I didn't call it Artificial Insemination School. I called it Ranch Management School because I wanted them to see the results of different things that were available to them. As an RN, I knew what genetics and nutrition were all about.

"We plowed everything we could back into the land…through conservation, through testing the soil, through doing it properly. I come from Washington State where everything is green and there is lots of water and trees. I was very concerned that there wasn't enough here. I wanted my kids to know where fruit came from, you know? Henry's that way too. So conservation is very important. Mother Nature will take care of and preserve her land. Even though people want to overproduce, she will take that decision out of their hands, and the winds blow and the dirt flies. So if you are going to stay on the land, you've got to put everything back into it that you can. The best advice I can give people is to get up in the morning and say your prayers. And if you want to ranch, go for it. It's going to cost you a lot of effort and a lot of time, but it's worth it."

The beaverslide was invented in 1908 in Beaverhead County, Montana, and is still used on the Stucky Ranch. Up to 1,500 pounds of hay can be loaded in the forked basket, or "head," as it sits flat on the ground for loading. A pulley and cable system hauls the head to the top of the boom poles, where it is dumped on to the stack. A wench truck has replaced the horses that used to power the system. The average size of a haystack is twenty-four tons, 2014. *Courtesy of the Stucky Ranch.*

change our lifestyle." She would, however, like those who don't ranch to understand the challenges they face. For example, elk numbers are up, and when hundreds of them tear down fences or get into the hay stacks, there's a conflict. There are also problems with wolves and other predators, as well as noxious weeds in need of control. "We have to be conscious of taking care of the earth, but there is a certain balance between being able to continue our operation, still care for the land and leave it better than it was," said Glenna. "That's hard for people to understand sometimes. We just need to let them know about our challenges."

She also would like people to understand the value of beef both as part of a well-balanced diet and a homegrown source of food. "It is easy for some people to think that somehow there will always be food that can be imported from another country," she said. "I think that is short-sighted. We need to convince everyone that our country can supply our own food and be self-sufficient. That's what we do: we supply safe, healthy beef as a source of protein, and there is nothing like it."

LEILA "CORKY" JOHNSTON FRENCH
PHILLIPS CONSERVATION DISTRICT

Corky French still lives on the same hill she was born on more than seventy years ago.

"I was born right here in this house because it rained that day. It was before there was much of a road to town and no four-wheel drive. I always liked it and thought it was a good place to live. I was in high school before there was electrical power out here, but we had a wind charger and batteries in the basement to have lights, and we had a refrigerator. We hauled water to a cistern, and then we did have a pressure tank to have a faucet but we didn't have any bathroom. After Bill and I were married, my folks moved into Malta, and we took over this place. Bill was putting up hay down in Saco on a meadow for half the hay, and we fed it to cattle for half of the calves. It takes a little while to get going that way. We lived here for ten years, and then we bought my aunt and uncle's place down below. I thought I was in heaven having a double sink to do my dishes in and a bathroom inside the house. We lived there for thirty-three years and then moved back up here.

"I've always liked to help with the riding, but now I've traded in my horse for a four-wheeler. I still help a certain amount with moving the cattle around. I don't get into checking heifers much anymore, but I have done a certain amount of that. Bill and I do most of the haying. I do swathing and raking, and he does the baling, swathing and raking. Then, of course, I do the ranch books and cattle records we keep. We have three generations of our family working on the ranch—our son and his family, and now we have a grandson who's just started working for us. Four of our five children are involved in agriculture. I guess I want my legacy to be that this ranch will continue on and that some of the family will always be here. Living on a ranch is all I know and was what I always wanted to do. When Bill and I were going together, we thought that it would be kind of nice to get a ranch in the Bear Paws. We thought that we would just get started here. But we never got around to leaving. Well, it'd take a hell of a mountain ranch to be as good as this one."

Glenna is a longtime advocate for agriculture and was recognized for her work as well as her success as a rancher in 2013 as Ranch Woman of the Year by the Montana Stockgrowers Association. Some of that advocacy includes her community work. As a member of the Avon Get Together Club, for example, she helped put together *Our Neighborhood 2000*, a compilation of family histories that, among other stories, captures those of the many ranch operations in the area that are third, fourth and even fifth generation. Glenna also served as a local 4-H leader for thirty-five years. The organization has been a thread throughout her life, down to the 4-H license plate on her car. Not only were Glenna and Earl members of the same 4-H Club for several years growing up, she worked as a secretary for the Bozeman and state 4-H offices early in their marriage as well.

Part of Glenna's commitment to her community stems from its location. "We're not as isolated as eastern Montana, but it is a thirty-eight-mile drive to Deer Lodge and nearly fifty miles to Helena. That makes community events so very important," she said. One of the biggest events of the year is the Avon Turkey Dinner, a community potluck organized and staffed by volunteers to raise money for the Avon Community Club. It was started in 1965 and draws hundreds of people who pay a minimal fee for a full-course turkey meal with all the trimmings. Glenna organizes the lists of food and work schedules of those on the serving line and in the kitchen in addition to

When Glenna Stucky can get away from the kitchen and cooking for the hay crew, she likes to operate the buck rake, which gathers the hay and moves it to the beaverslide basket, 2014. *Courtesy of the Stucky Ranch.*

cooking a turkey and three pies. "This is a great day of working together for the good of the whole community," she said. "In 2017, we had about 120 people working, bringing food, cooking turkeys or helping in some other way. It takes a lot of coordination and cooperation from everyone." She also helps with the Avon Country Christmas Bazaar and other Get Together Club projects, including compiling and publishing cookbooks.

The Stucky Ranch is a multigenerational operation, and now more than forty years after taking it over from the Keileys, Glenna and Earl are beginning to leave some of the more grueling work to others. But that doesn't mean they've slowed down. Although Glenna had to give up riding horseback after her knee surgery, she continues her ranch responsibilities along with gardening, sewing, playing the piano and other lifelong activities. Travel doesn't interest her much other than the occasional short trip with Earl or one of her children. Joy comes from being with the family on the ranch doing what they all love to do. Glenna particularly delights in watching her great-grandchildren learn the lifestyle she loves so much. "Kids who grow up on the ranch learn how to do chores, how to act around livestock and how to respect animals of all kinds as well as the world around us," Glenna said.

Her children and her way of life are her legacy, she says. "I cherish my life, and I wouldn't be happy doing anything else. I know that there are some changes coming—physically, we won't always be able to do what we like to do—but every day that we can, we will."

"Nature Adapts, and We Have to Too"

Donna Fritz Griffin

Liberty County Conservation District

As thousands of Montana homesteaders called it quits when severe drought hit in 1917, a pregnant Ila Fritz took to the fields with two toddlers in tow to keep the family farm going while her husband left to work for the railroad. It was an act of courage and determination that continues to inspire her granddaughter today. "She was just nineteen or twenty years old and alone," said Donna Griffin, who farms along the Hi-Line just a few miles from where her Grandma Fritz farmed a century ago. "Her family had homesteads nearby, and when the hard times came, they all left. They begged her to go with them, but if she had, the Fritz family farm would have been lost. And I just think, what strength she had, what character."

That same familial strength and character were once again in evidence years later when Donna chose to stay on her farm after the devastating losses of both her adult children and her husband. Just as Ila was urged to choose an easier path, Donna's family and friends suggested that she sell and retire to an easier life. But she needed the land. "It was truly my saving grace," she said. The daily demands of caring for her crops and her animals provided continuity when she needed it the most, while honoring her family's legacy gave her purpose. "The biggest decision I will make in my lifetime now is how do I preserve their legacy. Unfortunately, my family didn't live long enough to enjoy the fruits of their labors, so it feels doubly important to me to respect their hard work and their sacrifices. My goal is to pass this land on to another family who can have as wonderful a life as we had here."

Donna Griffin and her dog, Fritzy, 2015. *Courtesy of Gail Cicon, Liberty County Conservation District.*

In many ways, it was an unexpected life. Donna grew up intent on becoming a physician despite what she calls an idyllic childhood on her parents' farm, where her days were spent riding her pony across the prairie. Her dream was to follow in the footsteps of her heroes, Drs. Albert Schweitzer and Tom Dooley, and provide medical care to the needy around the world. "I never thought once about coming back to the farm," she said. Then she met Robert Griffin at an O-Mok-See in Rudyard in 1963. "I was barrel racing, and he was having a good time," Donna laughed. "Maybe I shouldn't tell this story, but most old cattle people aren't much for Palomino horses. They are sort of considered showy, a dude horse. Well, not only was he intoxicated, he was riding a Palomino. I always said I could forgive him for being intoxicated but for riding a Palomino?"

Their chemistry was immediate, and despite Robert's questionable taste in horses, Donna and Robert quickly became a couple. The relationship soon challenged Donna's assumptions. Robert had grown up on a farm in northern Montana, and he thought they should get married, buy their own place and raise a family. Donna thought they should both go back to school,

MICHELLE GEARY HOLT
NORTH POWELL CONSERVATION DISTRICT

Michelle Geary Holt's great-grandfather John Geary was one of the first settlers in the Blackfoot Valley, homesteading in the mid-1800s. In 2014, Michelle and other fourth-generation members of her large extended family began facing one of the greatest challenges that confront family farms and ranches.

"This is where a lot of family ranches fall apart. You get to a point where you need somebody to look at it with a good clear mind and as a business and to push back the family ties and make business decisions that will keep the ranch going. My dad and his siblings did not do that, so now there are sixteen of us in the fourth generation. Because there is no plan of how to keep passing the ranch down in terms of keeping it in the John Geary lineage, it is frightening to think of the very real possibilities. My kids are fifth generation; my grandkids are sixth generation. Do I give up the fight and give them no hope of being able to go out there and take a walk along the Blackfoot River or Nevada Creek? It's hard, but we're not unique in that sense. The ranches that haven't made it out there, that weren't passed down to following generations, are now owned by conglomerates. To go down in those sagebrush pastures and go on old trails that my great-grandfather's cattle carved, what a tremendous sense of connection to all that really matters."

and she'd become the doctor she'd always wanted to be and he could become a lawyer. Robert's dream eventually won out. "It was a very big decision but it was absolutely the best decision I made in my life," said Donna. "It brought me the most happiness."

The couple married in June 1964 and moved to Great Falls, where Robert worked construction as they began saving for land. In 1972, with the help of their families, they were able to put together the $27,500 needed for a down payment on a 640-acre wheat farm outside of Chester, near her parents' place. The first years were difficult. Robert worked nights at Tiber Dam and farmed during the day, while Donna raised their children, Kyle and Karla,

Donna Griffin spent many days of her childhood riding her pony across the prairie. She was seven years old when her incessant pleading finally convinced her parents that she needed her first pony, 1952. *Courtesy of Donna Griffin.*

as well as a big garden, 6 milk cows and about 250 chickens. In addition to pasteurizing and selling milk to her neighbors, Donna sold them cut, wrapped and frozen chicken for $1.50 a bird. Any spare time the couple had was spent with their horses, a lifelong shared passion. "It was a struggle, but it was like my Grandma Rew always told me, when your kids are little and you're busy, those are the best years of your life."

As time went on, the Griffins were able to lease another 320 acres and start running cattle. Through it all, the couple approached their decision-making as equal partners: "We learned a lot of lessons together. I think one of the unique things about Robert was that he respected women. I see so many men who think agriculture is outside of a woman's realm, but he always took my opinion into consideration. In fact, I think that held him down the first years. One of the few arguments that we ever got into was about buying a piece of land north of us. A neighbor wanted us to take over his payments, but I was just too afraid of the debt so we didn't do it. Of course I feel very differently now. Once I got my feet under it, I could see how capable Robert was."

As they expanded their holdings, stewardship was always a guiding philosophy. Donna traces her views on conservation back to a conversation she heard her father, Raymond, have with a neighbor when she was about eight years old: "You know how kids listen in on adult conversations. My dad was a hunter and he said, 'There's a really big buck, and it's such a grand specimen we need to leave him.' Then he talked about how we needed to leave the best-looking does and the fox that had the best fur coat and color, and that we don't just take from the land and take from the animals that run the land. We conserve them so that they improve as well. I remember that so distinctly because I had never heard my dad talk about much, and it certainly gave me a feeling that we are stewards of the ground. We don't just take, we look for what is best for the environment, for that animal, for that piece of ground."

One of Donna's favorite books is *If You're Not from the Prairie*,
by David Bouchard.

You see,
My hair's mostly wind,
My eyes filled with grit,
My skin's white then brown
My lips chapped and split.

I've lain on the prairie and heard grasses sigh.
I've stared at the vast open bowl of the sky.
I've seen all the castles and faces in clouds,
My home is the prairie and I cry out loud.

If you're not from the prairie, you can't know my soul,
You don't know our blizzards, you've not fought our cold.
You can't know my mind, nor ever my heart,
Unless deep within you, there's somehow a part...
A part of these things that I've said that I know,
The wind, sky and earth, the storms and the snow.
Best say you have—and then we'll be one
For we will have shared that same blazing sun.

—Excerpt reprinted by permission of the author.

Donna Griffin and Cindy, the first horse she trained, 1961. They worked cattle together, competed in O-Mok-See and barrel raced. Donna's dad would make sure that she had tapaderos, or hoods for the front of stirrups, to prevent Donna's feet from slipping through. *Courtesy of Donna Griffin.*

One of the first major efforts Donna and Robert took to improve their ground was to move to chemical fallow. Farmers leave parts of their land fallow, or bare and out of production for a time, to allow moisture to seep deep into the soil to support the next growing cycle. Traditionally, the land was tilled periodically to break up the weeds but otherwise left alone. With chemical fallow, the land is kept out of production, but rather than tilling, weeds are controlled by applications of herbicides. Not tilling was controversial at the time the Griffins started applying herbicides. "We heard from many of our neighbors that we would ruin the soil if we didn't stir it up," said Donna. "But the science has shown us that you don't work the

ground, because you have to allow the microbes to grow. So it shows how science itself has changed so much."

As technology continued to advance, Donna and Robert next moved into precision agriculture, taking advantage of soil testing and upgraded equipment for precise application of fertilizer. They considered it both a matter of common sense and sound economics to give the soil what it actually needed rather than randomly spreading fertilizer. "We started using precision ag on the poorest, sandiest fields first, and we were amazed at the difference in the stand and overall health of the land within a few years. We weren't spending any more on fertilizer, just using it properly." Though she calls Robert the visionary, since his death in 2009, Donna has continued to adapt her farming methods as science and technology evolve. "You can't sit back. You have to be willing to change, and change is hard for people. But nature adapts, and we have to too. It's just part of life."

Donna's latest adaptation is moving from chemical fallow to crop rotation, and she believes it to be the most comprehensive approach for retaining moisture, building up the soil and confusing the weeds. "It is amazing how quickly weeds adapt and become resistant to certain chemicals, which is why people keep putting more and more chemical down to kill the same weeds that used to be killed with half the dosage," she said. "And there's always that one rogue weed that escapes and starts a whole new line of resistant weeds." With crop rotation, Donna follows a wheat or other cereal crop with a planting of legumes, such as peas and lentils. The legumes are followed by an oil seed crop, such as canola or mustard. After that, it's back to the cereal grains. That three-year cycle makes better use of the available soil moisture because legumes have a shorter root system and draw from the top couple of inches of the soil, while the oil seeds tap the moisture deeper down. It also disrupts weed cycles given the differences in species maturation rates and nutrient requirements. Over time, less and less chemical is needed, with the goal of eventually being able to stop the herbicide applications completely. Donna has already seen weeds come much later in the spring, and sometimes not at all, in places where she had peas and lentils.

Although it was a very big financial decision to make the commitment to a 100 percent crop rotation, Donna's knowledge of the science behind the approach convinced her it was a good investment. She is an avid lifelong learner. Not only does she attend every educational event sponsored by the Montana Extension Services and Research Stations that she can, she also reads about agriculture on a nearly daily basis. In fact, she says that farming is the perfect occupation for her precisely because it does require ongoing

learning. "I love to learn, I just love it," she said. Donna believes that one of the biggest misconceptions that urban people have about agriculture is assuming that anyone can do it: "There's that prevalent idea of the farmer with the straw in his mouth and the bib coveralls, but farming is a business, so don't underestimate our skills and intelligence. I almost think that there is a difference in the type of people who farm now. Before, people came out and homesteaded, and that was how they made a living. Now the people we have left in agriculture are the ones who really love it and are really committed to bettering it. The inefficient ones have gone by the wayside."

Love of learning can be called a family trait in Donna's line. She takes considerable pride in her maternal grandmother, Lena Stubbe Rew, who made many sacrifices to fund college educations for her two daughters, Jennie and Lillian, Donna's mother. "They were very, very poor, but she worked in town and grew and sold vegetables to put her daughters through school," said Donna. "She just felt very strongly about women getting an education, which at that time I think was really progressive, and she was a good business woman too." The most recent family member living Lena's

WENDY BENGOCHEA BECKER
RICHLAND COUNTY CONSERVATION DISTRICT

Wendy Becker grew up with three brothers on their parents' farm in northern Richland County. After getting her master's in animal science, she and her husband returned to run the family operation.

"I'm a centuries-old farm family, from my family in Europe and my grandpa's family. That's all we ever were. I feel very connected to it. I had always told my mom and dad I wanted to farm, always. But I was the girl, and I wasn't the oldest. Dad finally realized I was serious about it and made the decision to let me run the farm. It was before I finished school. I fed the animals, seeded crops, baled crops, did his bookwork. I did it all. I still wasn't the boy, but he got over it. I told him then, 'If I come back, I want to buy the place. I don't want to rent it.' He said that was fine, he was going to retire. He went from 'you can't do it,' to 'well, of course you can.'"

passion is Donna's granddaughter, also named Lillian, who is pursuing a career in veterinarian medicine. Donna's own desire for advanced education was fulfilled when she eventually returned to college and earned a bachelor's degree in psychology and human services. She had started pursuing a graduate degree as well but dropped out of that program in 1997 when her daughter, Karla, passed away unexpectedly. "If I went back now, it would be for a master's degree in business," she said.

Donna now farms nearly seven thousand acres, including the original farm that she and Robert purchased near Chester and the farm their son, Kyle, managed near Ethridge until his death in 2013. The three had purchased that place in partnership in the late 1990s. Kyle began farming on his own at age nineteen when he leased a neighbor's farm with the full support of his parents. As first-generation farmers, Donna and Robert considered both the advantages and disadvantages of being a generational farm. Robert, in particular, didn't want Kyle to be in his sixties and still waiting to make his own decisions. So when the opportunity arose to take over the neighbor's place, Robert helped Kyle negotiate the lease, then took him to the bank, introduced him to their banker and left. "I really respect my husband for that. He was willing to let his son make it on his own," said Donna.

Karla loved the rural lifestyle just as much as her brother did, but her life would take a different path. As a high school junior, her PSAT scores earned her numerous offers of scholarships and early admission to Bryn Mawr College, where she earned her bachelor's and master's degrees. She was working on a doctorate in psychiatry at Purdue University when she died, leaving a husband and two children, then ages five and one. "Her plan was always to come back to Montana," said Donna. "She was an innovator like her father and always had a lot of ideas. When she was in high school, her dad told her to buy some heifers, and she said, 'No Dad, there's more money in sheep.' So she ended up with a flock of sheep. She was always a Montanan, that's for sure, and a farm girl. That never left her."

Her children's love of the land is never far from Donna's mind and paramount to her desire to create a succession plan that will pass her land on to another family. "I know you can't control it from the grave, but I want to do as best I can at handing it off to someone who is going to farm it and then pass it on to the next generation. I don't want it to become part of a big corporation or go to someone who will sell it and live on the proceeds."

Donna Griffin (*right*) and her sister, Bonnie Fritz. Donna's steer won grand championships at the Marias Four County Fair, the Montana State Fair and the Golden Spike International Livestock Show in Ogden, Utah, 1963. *Courtesy of Donna Griffin.*

Given the generations of women in her family who were farmers and ranchers, Donna is also thinking about establishing a scholarship to help others interested in going into production agriculture. "You see more and more women in the research stations, and of course, they have always been the stalwarts of the Farm Services Association and conservation district offices, but I'd like to see more of them in production ag," she said. Although she is optimistic about the changes she's seen in acceptance of women as producers, she still sees plenty of challenges ahead—particularly given her experience as the only woman on a producers' panel during a conference for beginning farmers a few years ago. At the end of the discussion, the moderator asked each panelist to give one last single piece of advice, and two of them said to have a lot of boys. "I was flabbergasted," said Donna. "Here I was sitting a chair down from them. I wanted to say, 'Hey, what about me? I'm farming.'" She believes that part of the problem is that people continue to undervalue how much even traditional "women's work" contributes to the success of a farm or ranch by allowing husbands to farm and children to

inherit successful operations. Still, she is encouraged by the changes that she has seen. "It will be awhile for full acceptance, in our industry and outside of it, but agriculture is a wonderful profession for women."

These days, Donna doesn't spend the time in the field that she once did, but she continues to be part of everything that goes on. Although Robert did most of the physical work when he was alive, Donna helped with the cattle, harvesting, fencing and other tasks. That experience and their shared responsibility in all financial and land-management decisions helped ease the transition to running the farm by herself after his death—so did her mother's example. Her mother and father farmed and ranched together for fifty-eight years. When Raymond died in 1999, Lillian stopped ranching and continued farming on her own for another eighteen years until she retired at the age of ninety-two. "My daughter always said that we stand on the shoulders of those who go before us, and my mother certainly taught me a lot about farm management," Donna said.

After Kyle's passing, Donna turned to hired help to assist her in managing both the Chester and the Ethridge operations. In doing so, she faced a challenge familiar to many farmers looking for help now. Not all younger hires have the practical knowledge of how to work the land, and not all older hires have the technical knowledge needed for operating today's equipment. This generational knowledge gap makes it challenging to find capable agricultural employees. At the same time, the need is growing. "It's difficult for one person to handle it all now because it is such a big business. Taking care of everything—the fieldwork, the marketing, the financial planning—keeps one very busy. I think years ago, if you were a good farmer and you kept your fields free of weeds, you'd do okay. But now there is so much more to it, it requires a broad knowledge of global markets and astute business skills as well."

Despite her workload, Donna does make time for vacations and enjoys learning about new places and people. Wherever she goes, she promotes her lifestyle and takes the opportunity to educate people about agricultural issues that she believes affect everyone, such as taking land out of production to accommodate urban sprawl. Soil health also crosses the disconnect between ag and urban populations if people take the time to consider, say, use of fertilizer on their lawns and parks. Political trends also concern her. Donna hopes that conservation and other educational programs will continue to be funded and available. She would also like to see more trade opportunities for agriculture and wishes there was less concern about things like genetically modified food.

In the meantime, she adapts. "If someone had told me at eighteen that this is how my life was going to end up, I would have never believed it. But I am lucky that my husband and I were able to build something that can continue on," said Donna. As always, it goes back to the land. "It is hard to explain to people the emotional attachment you get when you've been on the land so long. You get such a deep feeling for it. It's an honor to be able to leave it better for someone else."

"After You Take Care of Something for so Long, It Becomes a Part of You"

Lauraine Whitworth Johnson

EASTERN SANDERS COUNTY CONSERVATION DISTRICT

When Lauraine Johnson first started attending Montana Conservation District meetings around the state as a member of the Eastern Sanders County Conservation District Board, she liked to introduce herself by saying that she was from Camas Prairie. Then she'd wait for their reaction. "I wanted to see how many guys would snicker, because this is known as the driest spot in the state," she laughed. "It was interesting to learn about what they were doing in the rest of the state; maybe they learned from me that if you are tough enough, you can farm or ranch anywhere."

Her quick-witted tongue-in-cheekiness aside, there is no doubt that Lauraine is tough enough. She and her husband, George, have ranched near Camas Prairie since 1972, surviving drought, wildfire, too many elk, even more weeds and the normal ups and downs of life on the range. It's a life she once thought she didn't want and one she now won't ever give up.

A member of the Confederated Salish and Kootenai Tribes of the Flathead Nation, Lauraine was born in 1942 "on the way to church," as she likes to describe it. Her parents, Fred and Harriet Whitworth, were ranching near Arlee at the time. "My mother would take the horses and wagon and go stay with her mom in town to go to church the next day and then come home. So this time she came home with me all bundled up, and Dad says, 'What's that?' We always laugh about it, but at the time, what he said made my mother mad."

Springtime at Lauraine Johnson's ranch, 2012. *Courtesy of Linda Brander, DNRC.*

Although her grandparents always had horses, Lauraine's parents were the first in her family to go into cattle ranching. Like most people, Lauraine has mixed emotions about her childhood. On one hand, she remembers that life on the remote ranch consisted of "work, work and work" as the family struggled to build their cattle business. But she also remembers the family having lots of fun: "One year, Dad worked for the Anaconda Company. They had a logging deal just off the reservation up the Jocko, so we got to camp out that summer. We lived in a tent, and there was this nice little dam there so we had a swimming hole. Other times we'd go up to Hungry Horse Reservoir and camp and pick huckleberries and swim, and once we got to go to the Calgary Stampede, which is a story in itself."

Lauraine met George during Thanksgiving weekend in 1960. Neither he nor Lauraine had any intention of ranching when they married in 1961. In fact, Lauraine said, "I told George I would never marry a rancher, and he said he didn't want to be a rancher." That held for about four years, with George driving a truck for a Missoula-based wood-chipping business and Lauraine taking care of the house and a growing family. Then they

heard about an eighty-acre farm for sale that came with twenty-seven cows. The couple was intrigued, and after Lauraine was able to get a loan from the tribal credit committee, they made an offer. "The guy backed out three times," she said. "He knew he wouldn't be ranching any more. Now looking back, I can understand what he was going through."

In some ways, the couple's life remained the same after they got the farm. George continued to work twelve-hour days driving truck during the week, and Lauraine raised the kids. But the first summer she was also moving sprinkler pipe. "Thank God it was only three-inch pipe. Most of the time it was just picking it up and packing it to the next location where the main pipe was, but that previous experience is why we don't have sprinklers at this place," she laughed. For the next few years, the couple would buy extra calves that were nursed and raised along with those born to their herd, and in May, they would move them all across the valley to their range allotment. Her dad would check them during the week, and Lauraine, George and their kids would ride their horses out on weekend checks.

The move to Camas Prairie came in 1972. By then, Lauraine and George had four children, and the whole family was growing weary of George's long hours on the road. "He'd get home at night just when we were all going to bed," said Lauraine. The 640-acre ranch at Camas Prairie was owned by her dad, who had purchased it in the 1960s. "George fell in love with it from day one," so when the chance to buy it came up spur of the moment, Lauraine didn't hesitate. "My mother had some surgery in Missoula, and Dad and I were in the waiting room waiting, and he said he was going to sell because he was too busy to run two ranches. And so I said, 'Well I think I deserve a chance to buy it,' and he said, 'Okay, you get one chance and one chance only.' So when George came home that day from driving truck, I said, 'I bought a ranch today.' He said, 'Okay. Where?'"

Camas Prairie is located in east Sanders County along Highway 200 between Plains and Dixon. Named after the blue Camas flower that once covered the plains, the upland prairie country has an average rainfall of just twelve inches a year. "My idea of a ranch is nice and green, and this does not stay green. Just in the spring," said Lauraine. Still, she concedes, there is beauty there. Outside her living room windows beyond the yard and corral are giant ripples that roll like sand dunes across the valley. The deep ridges formed about ten thousand years ago when the great Glacial Lake Missoula burst through a 2,500-foot ice dam and flowed toward the Pacific Ocean so

Jeanette Tomsheck Brown
Toole County Conservation District

Raised on a farm eighteen miles east of Sunburst, Jeanette Brown moved to her husband's family ranch near Whitlash in 1948, where she lived for more than sixty years.

"I just loved it because I was raised on a farm with no trees or even grass in the yard. When I married into the Brown family, I moved to a place with fifty or sixty big cottonwoods in the yard. A lot of women would go work out in the field with the men; I admit I never did. But when the men come in, the meal was ready on the table. There was always meat, potatoes and bread and butter. Everything you did was conservation. Like your alfalfa field, every so many years you had to plow that up and reseed it. But to be honest, my husband was a rancher not a farmer. So it wasn't too long before he had everything planted back into grass. Today the ranch is ten thousand acres. My two grandsons are the fifth generation of Browns to be on it."

quickly that the lake drained in a matter of days. "It's really pretty in the spring when the snow's going off and you get the snow in the ridges like somebody just went and made them," she said.

The Johnsons made the move to Camas Prairie fairly quickly, and George quit driving to ranch full time. The family thrived and their home soon became the place where all the high school rodeo kids wanted to be. "I was feeding them all. My biggest problem was not having enough large pots and pans," Lauraine joked. "One fall I think I did like three hundred pints and quarts of jam and jelly and stuff that I could feed kids. But that's the way we grew up. When I was a kid we used to go pick cherries, and one year, we put up three hundred quarts of just Flathead cherries. Then we would go up to Hungry Horse and pick huckleberries until they came out of our ears, and find wild apple trees and make applesauce. That was just the way of life. So when I got married, that's what we did too, and then we only had to worry about the beef and potatoes."

Turns out that the beef wouldn't be a problem either, although the Johnsons had to adapt their production process over time. When the family

first moved to the area, they were able to put up around four hundred tons of hay to feed their cattle; but given increasingly dry conditions, a large elk herd that migrates through and some issues with trespassing cows, they now find it easier to just purchase hay. "If we had some good years of moisture, maybe we would hay some of the land we have, but we can have 50 to 350 head of elk," said Lauraine. "Thank god, they move around. If they came and stayed, I don't know what we'd do."

Over time, the Johnsons have increased their lease holdings to about twenty-two thousand acres to allow them to run more cattle than they had been previously. Most of that is a tribal range unit that originally belonged to Lauraine's father, Fred. Lauraine and her daughter, Sheila, now hold the lease. "She has a few cows, and we put her on the lease in case something happened to me," said Lauraine. "And our son, Brad, is here now with us full time and has cows there too."

Conservation was always part of Lauraine's approach to living on the land. "Probably the biggest thing I learned growing up with my mother, who was a full-blood Native American, was to leave things better or back to the way that nature intended them to be." The enormity of that commitment became clear to Lauraine when they moved to Camas Prairie, she said. "A friend was always talking about 'raping the land.' I honestly did not know what he meant. I couldn't visualize how or what that was until we moved here. There was eight acres that had been farmed and farmed and farmed and farmed; just same old putting grain in every year until it was all thistles.…We ended up with it. We put in grain for a couple of years and then changed it to an alfalfa/grass mix and that really grew good. But what had happened to the land before us was a crime. I don't know why or how they were allowed to do such a thing."

One of the worst challenges the Johnsons have faced at Camas Prairie has been wildfire and its after-effects. There have been three fires so dangerous that they've had to evacuate, the last in 2000 when the south end of the ranch along the Flathead River burned. An earlier fire came within a half mile of the house and another to their fence line. "After the fires, the shrubs and brush took over before the grass could get established, and then came the pine trees," said Lauraine. "The young trees come up as they call it, 'thicker than hair on a dog's back.' So when you are out on the range, there are places where you can hardly negotiate or see through the trees." Ironically, many of the conservation practices Lauraine gleaned during her years on the conservation district board are not suitable for their property. Water conservation via irrigation doesn't apply for example, as they depend

MARY SEXTON
TETON CONSERVATION DISTRICT

Mary Sexton has worn many hats throughout her life, including that of director of the Montana DNRC when the Montana Women in Agriculture oral history project started. Her connection to the land along the Rocky Mountain Front has been a thread throughout it all. Mary now lives on the ranch southwest of Choteau that her parents bought in the 1950s.

"It's the place I've always come back to. My grandfather came to the Choteau area in about 1905 and was the town doctor there for many, many years. He also raised turkeys, cattle and horses. Choteau had a community band then who performed on horseback, and he often would give horses to people who wanted to use them in the band. I went to school in Great Falls but spent all of my summers out on the ranch. Later, I worked for some outfitters, and then I became a teacher. In the late 1980s, my father passed away, and so I came back to the area to take care of my mother. My husband and I managed the Nature Conservancy's large preserve west of Choteau. It was about twenty thousand acres, and they leased it out to neighboring ranchers for grazing. A lot of the people who'd come to visit came from the East Coast, and they often asked, 'Why are you grazing cattle?' I'd tell them, 'It's a ranch, and traditionally bison had been in the area so it was an ecosystem that existed with grazing. Cattle were a natural and a very necessary part of the environment.'"

on snowpack. "When the water comes, whether it's February or March, we have our dams out and flood irrigate. Come July you can tell how much water you had by the better hay." Some years, they only irrigate a week or two, others maybe a month. "We don't know when we will start, and when it's over, it's over," said Lauraine.

Lauraine gives credit to those who can and do use no-till drilling, irrigation and other conservation practices where possible. She would like to see an even greater effort in weed control. "I don't remember the wording, but in the Bible it says something about people being hungry

and famine, and I thought, gee, in America nobody should ever have to go through hunger. But then I thought, you know, weeds could do it." Noxious weeds are an expensive threat to ag and non-ag lands alike. They decrease forage for livestock and wildlife, push out native plant species, reduce plant diversity, increase soil erosion and more. Weeds didn't seem to be an issue in the early years on the ranch, but then things changed. Toadflax was the first invasive weed on Lauraine's radar: "Then, I don't know if it was the fires or the drought or what, but it seemed like all of a sudden knapweed came in with a vengeance. Everybody had it. Then one day we woke up and we had white top. At first we thought it was from some hay that was brought in, but now I'm thinking that the birds brought it in because it's along the fences and growing up in the rocks. So that's my biggest thing. If people are going to spend money on conservation, they better look to see about getting rid of the weeds first."

Lauraine believes she and George have a good handle on conservation management. "We probably could raise and run a lot more cattle than we do if we didn't have the elk and the deer, but I've said that we must be gosh darn good conservationists because we have enough grass for our cattle and for the deer and the elk and the sheep. So we're pretty proud of how much grass we leave in the fall."

All and all, it's been a good life at Camas Prairie. Lauraine readily admits that there have been times throughout her ranching life that she thought she could just as easily give the ranch away as keep it—such as when George went back to driving truck and working construction just a few years after they moved to Camas Prairie and much of the management was back on her shoulders. But when Lauraine and George both had serious health issues and faced the reality of leaving, she couldn't do it. "It was an eye-opener for me," she said. "I realized that I had really come to love this place. I guess after you take care of something for so long, it becomes a part of you." The peace and quiet is particularly dear to her. "I tell people we're twenty or thirty years behind the rest of the world. We've got good neighbors, where your word or a handshake is enough," she said.

The flexibility of dryland farming and ranching is also an asset in that they are not as tied to the place as other ag producers might be. "If there is something that we want to do, or a place we want to go, we can arrange things and go." Lauraine has never lived more than forty miles from where she was born, and other than the Mission Valley, there is no place she'd rather be. Her one acknowledgement of her personal vision of what a "real" ranch should look like is a photograph that she took in the spring. "I had it

BARBARA HABETS
PONDERA COUNTY CONSERVATION DISTRICT

Barbara Habets's introduction to the realities of an agricultural lifestyle came when she and her husband, Mike, returned to his family's farm after they both graduated from Montana State University.

"As the years went on, I became more and more involved in the farm to the point that one year I seeded winter wheat in the fall and the following summer was the one who combined it. Our lifestyle has been very gratifying. Farming allowed us to raise our family in an environment where they were very involved with us, as we were with them. We always considered it a family project. Conservation was discussed at our dinner table, and one of the things that we emphasized was water conservation, because we realize the value of water. We think it will be the most valuable resource in the years to come. Mike has been involved in a salinity group and is the chairman for the board of directors at the Tiber Water District. So I think our kids would say that water conservation was what we drilled into them the most. Our children have fond memories of growing up on the farm, which to me is a wonderful thing. A lot of families are under a great deal of stress during harvest, but that was never the case at our farm. My husband considered it a time of celebration. That's the culmination of all of your hard work for the year, so it has always included a lot of playfulness. We've had feast and we've had famine, but throughout it all I can't remember which years were which."

blown up for George for a birthday present. I told him that if I have to see this view all of the time, I want to see it green," she laughed.

It just might be that Lauraine's good humor is what holds it all together. As she says, "If you're not positive, you might as well quit." But don't discount her tenacity. "What I call real ranch women are doing their share about putting the land first, the ranch first." Lauraine is quick to acknowledge the help they've had—what she calls "being in the right place at the right time

with the right people"—but she believes success also comes down to the choices people make. "When George and I started out, I had two cows, and from that we have well over two hundred cows and the ranch is paid for. To be able to ranch you have to give up something. You have to prioritize your time and your money."

Lauraine and George will leave the future of their ranch up to their children, Sheila, Brett, Brad and Steve. All have families and careers of their own. "I don't want to interfere with their lives. It will have to be the decision they make," she said.

They would do well to follow in her footsteps. When asked what she wants her legacy to be, Lauraine doesn't hesitate: "To live an honest life. I don't think that we have done anything that we should be ashamed of. Our kids and all of our grandkids are all working, and I think that was what our parents instilled in us is work. If you work and you have your dreams and your goals, then you can accomplish them. All of the bumps in our road, there was a way around or under or over them, something. You can accomplish what you want.…And a good prayer life is essential—with it, life has been easier."

"Certain Horses Will Just Take Care of You"

Betty Johnson Hedstrom

Judith Basin Conservation District

Like many ranch accidents, this one started with a horse, a cow and a dog. It was calving season and Betty Hedstrom was sorting cows so that those closest to delivering would be nearby. "We had a new dog that was just a pup, and I was riding a colt. The dog came in and heeled my horse, the horse exploded and I shot like a torpedo up over the top of his head. Then the horse proceeded to run over me and stepped on my ankle." Betty ended up with compressed vertebrae in her neck, separated vertebrae in her back and a broken ankle. After a week in the hospital, she was sent home in a neck brace, back brace and ankle cast, with strict instructions not to lift anything that weighed more than a pound. She had the cast for six weeks, the braces for months. At the time, her three children were five years, three years and ten months old. "We got through it. Steve didn't leave me, but we had our ups and downs," Betty laughed. Though she jokes about what her husband had to take on during her recovery, the partnership the two share belies any real discord. Also, he had had his own serious accident a few years earlier.

Betty and Steve run a cattle operation at the far western edge of Judith Basin County, near Raynesford. They met when both were studying ag business at Montana State University and married on Valentine's Day in 1976. Betty grew up on her family's ranch, which has existed in one form or another since her grandfather homesteaded in 1889. There was never

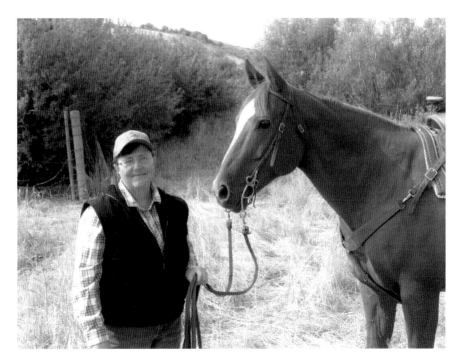

Betty Hedstrom with her horse, Freckles, 2005. *Courtesy of Hedstrom family.*

any question that she and Steve would return there after graduation. "We didn't discuss it a lot, but I was always going back," she said. Five weeks after they married, the couple went to the ranch for spring break, and there was a freak accident. Steve was helping feed the cows when the tractor flipped and landed on him, crushing his leg. He seemed to be on the mend after surgery and three weeks in the hospital, but gangrene set in, and his leg had to be removed right above his knee. "It didn't really stop him," said Betty. "He would hop on his crutches to the tractor, then he baled all summer with his crutches tied to the roll bar of the tractor." Steve got a prosthetic leg in August, and the two returned to school that fall. "We decided that since we missed spring quarter, we would double up on credits so that we could still graduate the next spring," said Betty. "Then we moved back to the ranch. Steve did all of the mechanic work for the ranch corporation, and I went back to working the cows and breaking horses," said Betty.

Horses are central to Betty's life. "You get a real bond with a horse," she said. "They are willing to do almost anything for you, and you know that they will be there for you in good times and bad. Certain horses will just take

Melody Harding
Big Horn Conservation District

Born in Lander, Wyoming, where she spent most of her childhood on her grandparents' cattle and horse ranch, Melody Harding owns Scarlett Hills Ranch outside of Hardin with her partner Bronc Maloney. Her passion for riding goes back to her earliest memories of being on a horse with her grandfather.

"Mom said, 'You were just days old and he was draggin' you up on the horse in a blanket, and he'd be gone for hours and hours. Then he'd come back in and say the baby needs her diapers changed, and we'd change your diapers and off he'd go again.' He was a good, good horseman. I was really lucky to grow up around him. We did not have a pickup at my grandpa's. We were about twelve miles from town, and he had a pair of buckskin Tennessee Walkers, well, part Tennessee Walker, but they were good-sized horses and boy they could trot like crazy. He'd hook those up, and he and I would trot into Lander and get groceries. It was amazing how quick they could go. I think that any woman is as capable as any man if you discount the physical strength, and there is always an alternative to brute strength. The main thing is to be truly capable and not be tryin' to half-assed do a job that you can't do really. Sometimes in a lot of different areas women are better because they are a little more caring and they have a little lighter touch. They might have a little more instinct than men. So, you know, women definitely can be just as good. But it takes a toll on your body; you pay for it because you're not built for all of that. Retiring isn't part of my dialogue I guess. I'll just work till I can't work no more."

care of you." Betty broke her first pony at eight years old and her first horse at age ten. "My older brother, Walt, started breaking horses when he was in high school, and people started bringing them to the ranch. Then he went off to school, which left us girls to train the horses. We would keep them for a month to six weeks and ride them every day. Everything we did, you rode. So once you got a colt good enough to line out, you would go out and ride four

to six hours, whatever it took, and you'd get a broke horse in a short amount of time." Her dad encouraged his daughters, telling them that it was a job and that they were responsible for getting it done right. "We only got fifty dollars a month for it, but I enjoyed it and considered it a job. It was how I earned money to buy my first car. By the time I graduated from high school, I had probably broke twenty-five horses."

Wrecks happened but just made her more determined. One day when she was out riding with her dad, he had her horse on a lead line because it was giving her some trouble. "We were just above the corrals, heading up the hill, when the horse throws a fit. But he's on the lead rope so he gets jerked back. As he starts to buck, he throws his head up and slams me right in the face. It's probably one of the only times I've ever had a bloody nose," said Betty. When her dad asked her if she wanted to get off the horse, she sputtered, "No I don't want to get off of him. I'll never get back on if I get off." Her dad figured that as long as they were going to keep riding, they should go round up the neighbor's yearlings that had gotten in with their cows. By the time they were done, Betty's horse was behaving himself, and her dad removed the halter. "I never had to have him on a lead again," said Betty. "We used to do things like that all of the time. Dad didn't like a 'broke' broke horse. He always rode a 'fairly' broke horse. He said that it was in case one of us kids got into trouble, he needed something he could rely on."

Betty is the sixth of Anton and Mary Ann Johnson's eight children. In addition to Betty and Steve, three of her siblings and their spouses also returned to work the ranch after college. Anton and Mary Ann had added three other ranches to the original homestead over time and incorporated in 1970. By 1986, they decided that it was time to dissolve the corporation and split the land among their children while they were still capable of controlling the outcome. There were numerous family meetings and consultations with lawyers. Ultimately, the Johnsons came up with a plan that gave the families living there the option to keep the units of land they were working. Their other children would get other acreage, monetary compensation or a combination of both. Because it was important to Mary Ann that those with working units could be confident that they were going to be able to be successful with the amount of ground they were to receive, they all agreed that the families would lease their units for two years.

"I give Mom and Dad a lot of credit," said Betty. "Whether everyone was happy with the way it was split or not, you at least knew what you had and it was yours to work with. It had been getting too complicated with in-laws having different perspectives and everyone's children getting older. You can't

Betty Hedstrom; her dad, Anton Johnson; and her niece, Jill Becker Gilko, in her grandfather's restored carriage, once used by him to court Betty's grandmother, Magdalene, 1989. *Courtesy of the Hedstrom family.*

change the management practices or do anything really until the land is your own. In the end it really turned out quite well."

To make their lease pay, Betty and Steve added more cows to the few they had as well as sheep, which they raised for meat. They crossed Targhee ewes on Suffolk bucks. "We did pretty well. We were in very rough terrain, though, with a lot of hawthorn brush that provided a tremendous amount of cover for predators." They had good luck with their first guard llama, which would take the sheep out and not come back in until all of his herd was accounted for. "If there was a lamb laying under a little piece of brush, he would go and stand there until you came over and got it," she said. Unfortunately, the coyotes eventually killed the llama. "If it is just one coyote, the llamas do very well, because they are curious and they'll go see what it is and pursue the coyote. Coyotes hate to be pursued. But in a pack situation, one coyote will lure the llama and then the others will come in behind it." The Hedstroms got another guard llama, but predators remained an issue. When drought hit in the late 1990s and they faced the choice of cutting their cow numbers or getting out of the sheep business, they chose the cows.

Conservation became a big focus after Betty and Steve were deeded their land. Steve is a longtime board member of the Montana Association of Conservation Districts as well as the National Association of Conservation Districts. He also serves on the state Rangeland Resource Executive Committee and is chair of the Judith Basin Conservation District. "If they need a demonstration plot for something, we are usually one of the places they go," laughed Betty. One of the bigger projects implemented at their ranch was restoration of the section of Otter Creek that goes through their place. The creek was straightened in the 1960s when Highway 87 was built.

With the Highwood Mountains in the background, Betty Hedstrom checks on the cows and calves, 2017. The cattle graze this pasture for three or four weeks and then are rotated to another pasture. *Courtesy of Ross Campbell, DNRC.*

That increased the rate of streamflow, which led to extensive erosion and bank washouts. Betty and Steve worked with the Judith Basin Conservation District in the early 1990s to restore their section of creek by creating rock weirs, sloping the banks and seeding willows. In one particularly steep area they placed straw bales along the bank to create a toehold for forage growth. "Until then, riprap was always used for erosion, so this was a forerunner of what is done now," said Betty. "We had started to lose a lot of ground because of the erosion, and we thought that if we could do it without a whole lot of expense, it would work out well for us. And it did. The banks have healed and survived several floods since then."

Another situation required the help of Mother Nature. In 1997, a storm dropped over three inches of rain in a half hour and caused mudslides on the hills in their summer pasture. "The small creek through the pasture that normally ran two to three feet wide and ten to twelve inches deep came down the hill ten feet wide and five feet deep," said Betty. "When it got out to the highway, it was a good foot over the road." Because the storm washed out all of the silt from the creek bottom, the stream went underground a few years later during the drought, leaving the pasture without water. "We ended

up utilizing the water further up the creek by making small dams and then piping the water into troughs. We still had to haul water up there but not as much as we did at first." As years passed, the creek silted in again, and it is now running at normal velocity. "At the time, we talked to people about it, but nobody had any real brainstorms. It pretty much had to be a natural process," said Betty. "It took several years to heal itself, but it's amazing what Mother Nature can do."

As a result of Steve's involvement in conservation, he and Betty frequently travel to seminars and workshops and often come home with something new to consider, such as adapting intensive grazing techniques to dryland conditions. They started by dividing a few of the larger pastures. Rather than follow typical seasonal pasturing with a few cows over a long period of time, they put a lot of cows on the land for ten days to three weeks and then rest the pasture until the following year. That many animals in a small area can prevent weeds because the cows eat everything down, not just their favorite plants. "So by doing the intensive grazing, our grasses are actually healthier than they were before, and we are able to run more cattle than we used to," she said. They also plant sainfoin, a legume-like alfalfa, for hay. Not only does it like shallow rocky and dry soils, but it also doesn't cause bloat on cattle like alfalfa can at certain times of year, giving the Hedstroms more flexibility in using their native range. "I love going and meeting all of the different people from the different areas. Any time you go on tours or to seminars with an open mind you can usually pick up some new ideas," she said.

DONNA NIMS LENOIR
GLACIER COUNTY CONSERVATION DISTRICT

Raised in Frenchtown outside of Missoula, Donna Nims moved to the Hi-Line after marrying Jack Lenoir. The couple has farmed in the area for more than fifty years.

"Some say farming is a way of life. To me and my family, farming is our life. We respect what has been given to us and make it better for the future. If we neglect our land and abuse it, it won't be any good later when we need it."

Betty Hedstrom; her husband, Steve; and son-in-law, Mike Long, work together to brand and ear-tag a heifer, 2004. *Courtesy of the Hedstrom family.*

Betty credits her willingness to explore other options to her parents. Both Anton and Mary Ann were more interested in new opportunities than they were worried about what other people were doing when they were ranching. For example, they were the first in their area to cross Black Angus with Herefords and then with Charolais. "Their attitude was, if you can get extra pounds with crossing on Charolais, we'll cross 'em," said Betty. "We kept that three-way cross for a long time, and we did get some beautiful calves." There is also a deep passion for education running through Betty's family that feeds an open mind. Betty's paternal grandmother, Magdalen Johnson, yearned to be educated but ended up only going through eighth grade. Magdalen insisted that her children attend college and sent Anton to Iowa State College (ISC), where he met Mary Ann, whose family was just as committed to education. Mary Ann's mother and eleven out of her twelve siblings had college educations. Her father, who worked in the Extension Department at ISC for three years before becoming a rancher, established college funds for all of his grandchildren, enabling Betty and her siblings to get their degrees.

Betty believes education is even more important in today's global economy. "Ranching is a business, and it needs to be treated like one. You

JOAN MEYER SMILEY
CASCADE CONSERVATION DISTRICT

Raised in Queens, New York, Joan Meyer moved to Montana when she married Lloyd Smiley. She and Lloyd purchased the family ranch from her father-in-law in the early 1960s.

"We were thinking of having children, and I wanted to get it settled. You know how these family things go. So I encouraged my husband to find out if there was anything here for us. Me being from the East, I am more direct on questions and answers. But his father always tried to push my husband off, saying, 'Just keep working every day, and it will work out.' But I can't go on like that. I wanted to know one way or the other, is there something here or not. We lived in Great Falls the first year we were married. After he came home from the ranch every day, I would ask him if he had talked to his father, and he always said no. Then finally his father said yes, that he would work on something to sell us the place. So at least we knew where our lives were going."

need to be able to run a pencil, understand the business aspects of it, know the management. If you have an education behind you, you're more willing to research and learn different things to make it work. Otherwise you are going to be left behind." The Hedstroms' three children are well prepared in the business of agriculture. Their eldest daughter, Stacy, is a CPA; their son, Travis, has a degree in engineering; and their youngest daughter, Karen, works as a loan operation manager for a bank. Travis will eventually take over the management of the ranch, but their daughters also plan to remain connected to the land.

In the meantime, Betty and Steve share the work. "We've always done it as a partnership," she said. "It doesn't matter whether we're fencing or feeding cows, or whatever. I do most of the riding in the summer, and he does the mechanic work; it's a good trade-off. And if I'm down suckling a calf, which he hates to do, he has no problem putting supper on the table." Betty is glad to see that there is a greater appreciation now for the contributions that women make and that myths such as women's inability to run machinery are

Betty and Steve Hedstrom at the entrance to their ranch, 2017. *Courtesy of Ross Campbell, DNRC.*

fading. In fact, she says in terms of that particular myth, her family thinks that women just might do a better job. "They don't push it so hard. That and if something goes wrong, women will generally shut off the machine and ask for help, where a guy will try to fix it whether he knows what he is doing or not." Joking aside, though, she is adamant that even ranching women who are not involved in the outside work need to know about the operation and be included in the decision making. It helps them understand the demands and needs of the ranch and might even open the door to better working partnerships between couples. "I've known a few marriages where if the husband had given his wife any type of a chance to work outside, she would have. You have to have open communication, and women have to say, 'Hey, I want to do this.'"

Betty would also like to see more open communication among those whose passions about the land conflict. She worries that people who don't have direct contact with farmers and ranchers have a distorted idea of their lifestyle: "I think to a lot of people, Montana is back in the Old West, and I guess we really are the Old West, but we need to tell them what we actually do. There are so many groups out there that think we are the evil ones, and yet ranchers are the ones who have taken care of the land for all these years. Once you start talking to them, they learn about stuff like calving and feeding when the weather is the worst. I mean, we're probably one of the few groups that when the weather is the worst, we are out there the most. And it's a lifetime experience. The cows and the horses have to be fed even if there's not enough grass or you're in a drought. But if you take care of the land, it will sustain you."

"Don't Tell 'Em You're Good—Show 'Em"

Janet Goggins Endecott

Madison Conservation District

Growing up in the 1960s, Janet Goggins loved working cattle with her dad whenever she could. She didn't know that some people thought there were things she couldn't, or shouldn't, do just because she was a girl until she was old enough to help during brandings and other events at neighboring ranches. "It had never occurred to me that that was a thing," said Janet. "I was shocked. But my dad told me, don't tell 'em you're good—show 'em. So I just kind of stayed under the radar of those who didn't like me being out there and went on doing what I did." If she did run into a critic, she turned a deaf ear and kept working. And when she met a fan, she valued their comments even more, like the time she went to a branding outside of Townsend with her brother and caught the attention of two elderly ranchers who were helping with the vaccinations. "At the end of the day they came up to me and said, 'You are a real hand,'" said Janet. "To have those old guys who really knew how things should be done appreciate me was the best compliment I think I've ever gotten."

Janet still spends as much time as she can working cattle. Now a partner in Goggins Ranch, she raises Herefords and Red Angus with her brother, Pat. He and their parents, Bob and Cora Goggins, remain on the family ranch outside of Ennis, and Janet lives seven miles north on the ranch she and her late husband moved to in 2000. The cows move between the ranches depending on the season.

Janet's relationship with her father influences much of who she is. As Janet says, "He has a knack for cows"—one that she seems to have inherited. Bob and Cora moved to the Madison Valley in 1948 after their marriage in 1946. For the first few years, Bob worked as a herdsman for area ranchers, caring for their registered cattle that were sold to commercial operations as seed stock to introduce new genetics into herds. After saving enough to buy their own place, the Gogginses raised their own registered Herefords for many years. "Everything we did had to do with being outside and the cows," said Janet. "I remember getting up before school every morning, and Dad would fix a little sack of grain for me and I would get on my horse and go feed the bull in the field. I had to keep the cows away and just let the bull eat because he was working so hard and needed a little extra."

CORA AMDOR GOGGINS
MADISON CONSERVATION DISTRICT

Raised in Harlowton, Cora Amdor was new to ranching when she married Bob Goggins in 1946. Cora came to love ranching but admits that, as a town girl, she had a bit of a learning curve after the couple purchased their Madison Valley ranch in 1959.

"Bob would come in and say he needed help, so I'd go out. But there were times I didn't quite know what I was doing. He never said a word, but he'd get a certain look on his face and I'd go stomping into the house. I don't know any ranch wife that doesn't have that same story to tell. We moved here in April, and in August, there was the big earthquake. It happened in the middle of the night. There was a loud roar, the weirdest roar I've ever heard, and I thought, I wonder if it blew all of my clothes off the clothesline. But they were hanging just as straight and quiet and no breeze. There were reports that Hebgen Dam had gone out. It was a big dam. I didn't know if it would flood us, but some people thought it would. We worried all night and day. It was a scary time."

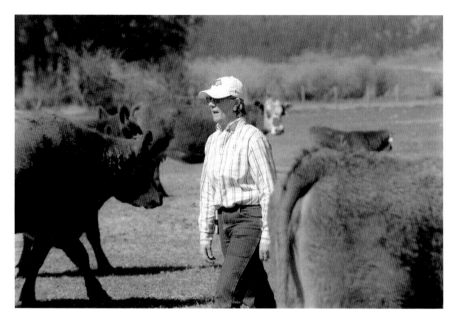

Janet Endecott checking her cows in the spring, 2017. *Courtesy of Eliza Wiley.*

The third of five children, Janet's biggest challenge then was balancing her inside and outside work. "I would try paying my sister to do the dishes so that I could go outside and help Dad," she said. After-school chores were never work. "It was always a love. Being with my horses, my dogs and the cows, there was nothing better growing up, and I still feel that way."

The whole family took pride in the bulls, making sure that each animal was halter broke and washed and curled for the sales. "I loved showing," said Janet. "We would hit the circuit in Montana at the state fair and in Billings, Butte and the local county fair in Twin Bridges. But going to the Denver Stock Show was the coolest thing. I'd get to skip like ten days of school in January." One of the family's favorite bulls was Britt, a champion Bob bought at the Calgary show. Britt was easy to work with, but he didn't like horses, and the Gogginses learned early on that when you dealt with Britt, you got off the horse and moved him by foot. "One day he got into the neighbor's place, and the neighbor tried to get him out with his horse. Britt did what he always did, chased the neighbor and knocked him down. So the neighbor called Dad, very upset, and Dad says to me, 'Go get a halter, we gotta go get Britt.' Dad took me down there to the pasture and sort of pushed me out of the pickup. Well, the neighbor was having a fit, 'Get that kid outta there. She's gonna get killed.' I walked up to the bull,

slapped the halter on and led him out," laughed Janet. "It's one of our favorite family stories. He was a fantastic bull, and we got some beautiful daughters out of him."

Goggins Ranch no longer sells registered cattle, but the Herefords and Red Angus are full-blood, with parentage and other aspects fully tracked. Janet and Pat have also developed a commercial herd, crossing the two breeds. "That produces an absolutely phenomenal female," said Janet. "It brings out all of the good traits of both and you get a longer-life replacement cow. She usually milks better and raises bigger and more calves, and pounds is what we sell."

When Janet married Bob Endecott in 1978, Bob joined the family business. He shared Janet's love for being outside, particularly on a horse. "I rode up until the week I had our daughter, Rachel, and was right back on my horse two weeks afterwards. She started going with us regularly when she was six months old. I'd get a pillow and stick it in front of me, between me and the saddle horn, and she'd straddle the saddle horn and we'd go for miles and miles," said Janet. Bob and Janet spent almost every day together. "We were best friends. That was the best part," said Janet "We could talk, and we were partners through the whole thing. You always had the little things, but we'd figure out the best way to do something and do it. Sometimes one would be right, and the other times the other would be right."

That close working relationship made it easier for Janet to manage the work on her own after Bob's death from cancer in 2016. On days when the workload is exceptionally heavy, Janet gets help from Rachel, who lives and works in Bozeman, as well as Pat. "I've leaned on my brother a lot, that's for sure. What I miss the most since Bob's death is talking things over, having someone to say, okay, we're going to go do this today." Janet's connection to her community has also been a comfort. "It is very tight-knit, you feel like it is an extended family," she said. "I don't know; it gives you the shivers. It's just who the Madison Valley is. You can't really separate the valley from the people."

Janet's sense of belonging feeds her long-held belief in giving back. In addition to serving on the local fair and hospital foundation boards, in 2002, Janet became the first woman to serve on the Madison Conservation District Board. She served as co-chair from 2003 to July 2017, when she resigned to free up more time for her ranch responsibilities. During her tenure, Janet's leadership helped trigger a new level of board involvement. "I'm not sure what they were expecting when they got me, but I've always sort of been a mover and a shaker. I think if you are going to do something, do it right,"

All sired by the same bull, these Endecott bull calves won first place in the "Get of Sire" class at the 1980 Montana Winter Fair in Bozeman. In this class, young livestock are judged on length, depth, thickness and muscling progeny traits. The bull calf Janet is holding was sold to the John Wayne Ranch in Arizona for $25,000. From left to right: Janet's dad, Bob Goggins; her late husband, Bob Endecott; her brother, Jim Goggins; and Janet. *Courtesy of the Endecott/Goggins family.*

she said. Proud to be the first woman on the board, she is also happy not to have been the last. Janet firmly believes that the best results are achieved by men and women working together. "Men and women look at problems differently, and the best way to solve something is to get both kinds of reasoning together to work out the problem. I loved it, and I am happy that the world is more accepting of women in these positions."

Although Janet didn't know much about the conservation district board when she was asked to join, her goal was to help ensure that agriculture remains a vital element in the valley as more and more of the land is developed. In fact, the family decided to sell their place on upper Meadow Creek where she and Bob lived for twenty-three years because of the development in the area. "We have a lot of people coming into this valley because it is so beautiful, and the reason it is so beautiful is because the ranchers have kept it that way since the 1860s when they started moving in here. Ag provides a good tax base, and it keeps the country useful," she said.

As co-chair, one of Janet's priorities was to improve communication between conservation district staff and the ag community to identify common goals. She believed that it would require patience and some give and take on both sides but that the effort would benefit all involved. What she didn't realize at the time was that she personally would be one of the first who would be required to exhibit more patience and a willingness to give. It began when conservation district staff started talking about fencing off a part of the stream through her ranch in 2010. "If you want to raise a rancher's hackles, start talking about fencing off water," Janet said. The conservation district was looking at South Meadow Creek to identify areas where year-round streamflow could be improved by updating the existing irrigation diversion systems. Janet's diversion stood out because it dropped the level of water to the point that brook and brown trout were unable to move upstream. When the assessment also identified a stretch of streambank significantly broken down by her cows, conservation district staff suggested fencing off the stream as part of a solution for improving both her irrigation system and stream habitat.

DIANA BURKHART GRAVELEY
BROADWATER CONSERVATION DISTRICT

Diana Graveley lived on the Graveley Ranch near Canyon Ferry Lake for more than thirty years, running the large cattle operation with her husband, children, in-laws and hired help.

"What I disliked the most was the stress. A lot of people ask me, 'Do I miss the ranch?' Yeah, you miss the ranch. You miss the fact that you can go out and jump on the four-wheeler and go to the mountains and look around some nice evening. You never get over that part of it. And a bunch of baby calves, to see them. One year we had such awful sickness in the calves. It was one of the times my husband was bed-ridden and couldn't get out. I was doctoring calves, and our oldest son was feeding cows. He'd talk to me about some sick calf, and I'd say something about another one dying, and he'd say, 'Mom, we have to save more of them,' and I'd say, 'I know.' There was nothing you could do. That's the kind of stress that gets you."

Cows and calves at the Endecott Ranch, with the Tobacco Root Mountains in the background, 2017. *Courtesy of Ross Campbell, DNRC.*

Janet was well aware of the effects of her cows on their favorite watering hole. "My place is used primarily for calving, so it gets very intensive use until June or so. We had over two hundred cows watering in the same spot where the creek comes down through here, and by spring when the ground starts softening up, it could be ugly. They were loving it to death." No vegetation, flattened streambanks and a churned stream bottom were all a concern. Still, words matter. "Fencing off water was what started all of the range wars in the 1880s, so the terminology probably wasn't the best," she said. "But after we talked about some things, we actually did end up fencing off the creek, or a better term—created a riparian pasture."

The three-year project was done in phases. In 2011, new wells and water tanks were placed in the pastures both north and south of the creek. The fence was put up the following year, blocking access to the creek and creating a narrow riparian corridor along the stream. As Janet theorized, giving can lead to taking; the benefits she gained were well beyond her expectations. Janet had been concerned that the cows would ignore the tanks and stay close to the creek, but they quickly came to prefer the easy accessibility of the tanks. Not only do they now drink whenever they want to, which improves their nutrition, they graze the pasture more evenly than in the

past because they aren't congregating near the stream. Janet was even more pleased by the amount of labor she saved with the new system. "I hadn't even considered how much it would simplify the operation. Before we were chopping ice and trying to find water when the creek would decide to move. It never would have occurred to us to put a fence here, but it makes it so much easier."

Today, the old watering hole has been transformed: grasses are thriving, willows have come back and the streambed has begun to narrow. When the cows are brought back to Janet's for a final push before they are sold, they might overnight in the riparian range if it's gone dormant or spend five or six days on the other pastures—whatever best suits the conditions. "We are now able to control the grazing, instead of having no choice but to let them in that pasture because they had to be watered," Janet said. "Our project shows that you can improve the ranching operation and the resource at the same time and that it doesn't have to be a huge thing. As a small operation, you can still make a difference."

Perhaps one of the reasons it didn't take long for Janet to agree to fence off the water was that she'd seen her dad do it years earlier. "The bulls watered on the creek, so it wasn't pretty at all. Through the years, Dad started putting

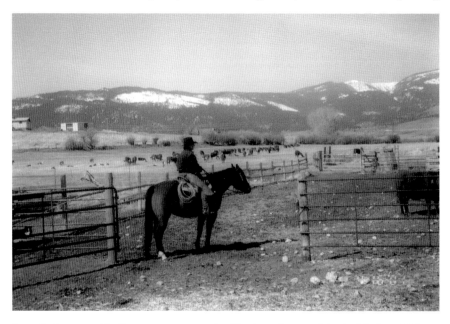

Janet Endecott astride Copper sorts cow and calf pairs at her ranch in the Madison Valley, 2001. *Courtesy of the Endecott family.*

tanks in and fencing off parts of the creek so there wouldn't be the daily use. But we didn't think of it as conservation. We just thought, boy, those bulls are doing a number on the creek so we'd better do something." Years later, and despite her passion for the conservation district's work, Janet still doesn't like the word *conservation* much. "I grew up thinking of it as taking care of the land. You do that, and it takes care of you." She particularly rejects the notion of those who equate conservation to taking land out of production. "There is conserving, and then there is protectionism," she said. "I don't think that's what conservation is at all. The word is so broad that I like to break it down into parts."

Janet would like to dispel any misconceptions about agricultural people: "I want people in ag to have the opportunity to make a living and raise their families so I struggle when I think about the misinformation that's out there. People are just so far away from the land that they have no clue of the extent that ag is keeping them alive. I think every woman with children wants to give them safe and healthy food, it's a pretty big thing. And so I want everyone to know that the U.S. is raising safe and healthy food, and we aren't doing bad things to animals."

She is also concerned about the lack of knowledge about the economics of agriculture, both in what it takes to make a profit and in the role that international trade plays. "Our future world partners won't be wanting our technology or our energy. It will be our food. And right now the American producer has the know-how, the work ethic and the pride to produce the most affordable, the highest quality and the safest food in the world," she said. "I don't know how to bridge those gaps, but every so often you hit a connection with somebody who had no idea, and I just love that."

In spite of her concerns, Janet remains an optimist. "Women are resilient for one thing, and ag producers in general are resilient. We just keep coming back because we know what we do is good." She is particularly heartened when she looks at her daughter's life. "I see her and these other young women coming up in the ag industry and becoming more active, and it makes me feel good. Every once in awhile, Rachel will mention that she had a little trouble with someone listening to her, and I'll say, 'Maybe it's because you are a woman.' And she says, 'Well, because of the way you brought me up, I don't even think of that.' I'm glad she doesn't. I think agriculture is much better for women now."

When Janet was a child, her dad frequently told her to make definite plans but to keep them flexible. "It was his big thing, and it drove me crazy as a kid. I wanted to know what I needed to do and when. I didn't want the 'be

Janet Endecott won first place in the goat-tying competition at the 1973 Ennis Junior Rodeo. *Courtesy of the Goggins family.*

flexible' part. But as an adult I understand it, and that's kind of how I try to live my life." When things do get hard, Janet draws on her love of the land. "It's a deep contentment that just kind of wraps around you," she said. "I love what I do, and I think I'm the luckiest person in the world to be able to do it. Not every day is perfect, of course, but I can look back and see so much good. The land gives life to everything."

"Basically, You Don't Waste Anything"

Margaret Small Julson

Back when flight attendants were stewardesses, Maggie Small Julson was working first class on a United Airlines flight to Chicago one day when one of the passengers started fussing. The plane was delayed at the gate in Reno due to a mechanical issue, and the man was worried that he was going to be late to a parade. Maggie looked at him, then said, "Oh, s---. You're the Lone Ranger." "Be quiet," said Clayton Moore. "I don't want anyone to know who I am without my mask on." Once the flight took off and the passengers were settled, Maggie sat down to visit with him for a while. "We probably talked for about a half hour before we landed. So about four months later, I was walking down the concourse, and I happened to look over and, dang, there he was again. I went over and said, 'I bet you don't remember who I am.' He took a look at me and said, 'I can't remember your name, but I know that your horse's name is Gambit.'" Such is the connection between horse people.

Maggie's fifteen years with the airlines was an interlude in an agrarian life. She grew up on her family's farm in Minnesota, lived for a time on a farm in Iowa, relocated to a ranch near Sheridan, Montana, and then settled on her ranch outside of Reed Point. Surrounded by cats, dogs, chickens, llamas, horses, a burro and a flock of Targhee sheep, Maggie is content. "I've had a lot of experiences in my life, so I'm really happy to just be able to sit back now and love this place. I definitely enjoy what I'm doing here and will do it until I'm about one hundred years old," she laughed.

Maggie Julson lets the sheep back into the main corral to feed. Before morning and evening feeding, Tucker, the corgi, herds the sheep out of the corral so that Maggie can throw alfalfa hay into the feeding racks, 2017. *Courtesy of Ross Campbell, DNRC.*

Small Ranch runs along Countryman Creek in Stillwater County. When Maggie and her third husband bought the place in 1990, it was in foreclosure and in need of extensive work. Over time, the barn once held up on one side by a telephone pole got a new foundation and siding, all the fences were replaced, grass was reseeded, trees planted, weeds controlled and new buildings constructed. Originally 640 acres, the ranch was split in half in 1997 when Maggie and her husband divorced; he got the top 320 acres and the equipment, and she got the lower 320 acres, along with the house, barn and corrals.

By then, Maggie had around two hundred sheep. Targhee are raised both for wool and meat and originated in Idaho. "They got their name from the Targhee Mountains," Maggie said. "They are a tough breed, more a range sheep than they are a flock sheep, so Montana is a great home for them." Maggie bought thirty ewes and a buck when she lived on the Sheridan ranch. Her first year with them produced a record lambing crop. "My first lambing was definitely a learning curve. The ewes knew what to do, but I did have to call a vet a time or two to pull a few of them. But two good friends had sheep, and I read a lot about it and talked to people about what to do."

JEAN PATTEN WALDBILLIG
GRANITE CONSERVATION DISTRICT

After growing up in Philipsburg, Jean Patten attended nursing school and then joined the U.S. Navy. She was deployed to Oakland, California, where she tended American and international soldiers who had been held as prisoners of war. Jean's life as a Montana rancher started in 1949, when she married Frank Waldbillig Jr. and moved to his family's ranch in the Flint Creek Valley.

"Chasing cattle was my favorite. I had a nice mare that Frank bought me, and the neighbors were always nice to include me in the cattle drives. I enjoyed that, I really did. Every time my neighbor Eleanor mentioned driving, that's where I'd be. I'd get up in the morning and drive the tractor, get my work done, get the meals over and then about 1:30, I'd go out and saddle the mare, and we'd go over there. She and I would ride 'til the kids came home from school. My roots are here. I think, without a doubt, this is one of the nicest valleys, and of course there are a lot of good people here. I think I've had the best of both worlds. I'm glad I came back."

Maggie still relies on friends to assist with lambing, sorting, vaccinating or shearing, depending on which task they enjoy doing. "They are really helpful. The lambing can be a lot of work, it's 24/7. I do it in the middle of April so I don't have to worry about the weather. It's wet but not freezing—because those lambs can freeze to death pretty fast." She admits to getting a little tired and grumpy about two-thirds of the way through lambing, but she still loves the season and the sheep. "I really enjoy watching the lambs play. Sheep are very gentle animals and easy to work with. Sure, I've gotten hit by a buck before, but pound-wise, there's a difference between a cow running over you and a sheep running over you."

Predators are the biggest issue with sheep. "A lot of people are getting out of the sheep business because of the predators," Maggie said. "I've got every guard animal there is, but I still lose some. I lost twenty sheep a few years ago, and that's my hay for the year." The next year, she kept cattle in with the sheep, thinking it might help keep the coyotes away, but she still

Guard dogs Mo and Badger patrol at night to protect Maggie Julson's sheep from predators, 2017. Both eight years old, Mo (*right*) is a cross between a Great Pyrenees and an Akbash. Badger is a Great Pyrenees and Anatolian cross. *Courtesy of Ross Campbell, DNRC.*

had big losses. Her long-term plan now is to move the sheep closer to the house, where it will be easier for the guard dogs to keep an eye on them. "I don't have woven-wire fencing around the perimeter down here, but that's the next project. Then I'll see if I can keep more of them alive," she said. Maggie does use traps and has considered other lethal methods, although she would rather not. "It's heartbreaking for me. But the coyotes have gotten just thick, and the bears have also become an issue. If you can get the ones that are causing the problem, it stops for a while."

In addition to her dogs, Maggie also has used llamas and burros as guards. Her animals have "starred" in a couple of PBS documentaries through Maggie's friendship with photographer and producer Ginger Kathrens, known for her film on the wild mustang Cloud and his Pryor Mountain herd. The crew brought in trained coyotes to stage the scenes at Small Ranch. "I was moving sheep around, and Ginger was filming, and the burro did go after the coyotes when they started mucking around up on the pasture. The llama did too," Maggie said, adding, "The man who trained the animals for these films said that the coyote is the most difficult animal to train."

Maggie's guiding philosophy is love of the earth. All of her ranch management decisions start from that point, including her use of herbicides and pesticides. Though she doesn't object to their use, she doesn't believe that the extent to which they are being used is healthy for the land. She limits the amount of fertilizer she applies and manages weeds by spot spraying. "There is no way you can avoid that," Maggie said. "I have a lot of water hemlock, which I didn't realize until I lost a couple of sheep to it a few years ago. And burdock is a big problem. If the burrs get into the sheep's wool, you might as well give it away. Nobody is going to buy it. So I'm real fussy about getting rid of those weeds. Other than that and sometimes on some thistle, I don't use it."

Maggie has always been vigilant about moving her sheep often to avoid overgrazing. She initially kept them off the upper pasture completely because the previous owner had planted alfalfa there. Maggie reseeded it with natural grasses and left it alone. A few years later, when she had staff from the Stillwater Conservation District out to consult with her on the condition of the ranch overall, they told her that the grass was reseeding itself well enough in that pasture that she could let the sheep on it. "So that's what I've done," she said. "The sheep are fantastic, because in the tall

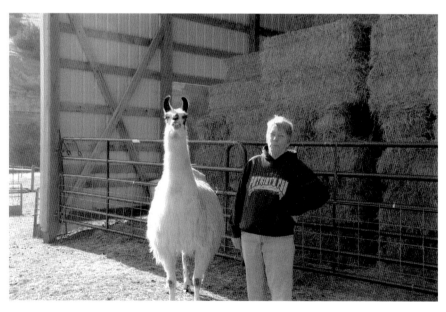

Maggie Julson and Sonny, her guard llama who died at age thirty, 2017. Llamas will stand in front of sheep and intimidate any dog or coyote that threatens the flock. *Courtesy of Ross Campbell, DNRC.*

native grasses they have a tendency to eat the bottom part and leave the top to reseed. I don't think it would have reseeded as well if it would have been just cattle up there."

One of the beauties of the ranch is its gravity springs. There was just one system bringing spring water to the ranch when Maggie and her husband moved there, and it had only about a thirty-gallon capacity. As soon as they could, they made it a priority to tap a second spring higher on the hillside and install a six-hundred-gallon holding tank. The large system supplies the house, and the smaller system supplies the outbuildings.

It was Maggie's second success with gravity water systems. When she lived in Sheridan, she earned the Ruby Valley Soil Conservation Outstanding Cooperator Award in large part for her installment of a gravity irrigation system. "It was a challenge. It had never been done over there, but for me it was fun," she said. Though they were met with a lot of skepticism, she and a neighbor found an engineer in Missoula to design a system for both ranches that brought water from the Ruby Reservoir into the irrigation ditch. Only one field had to be redesigned because the strong water pressure caused the pipe connections to fail. "It was phenomenal, it really was. All gravity. At that time, we had to pay for the electricity running the irrigation systems, and the pumps were expensive. The electric company let us out of our contract as we were the first to do it, but as more people started to move to gravity systems, they started charging a fee."

Maggie Julson bottle feeds a milk supplement to one-month-old lambs whose mothers were unable to nurse them. The "bums" are fed four to five times a day. *Courtesy of Maggie Julson.*

Maggie began exploring the idea of gravity irrigation when she was a member of Alternative Energy Resources Organization (AERO) and learning about sustainable farming. The concept took her back to her childhood on the family farm in southeastern Minnesota. "We didn't think of what we did as conservation practices. Basically, it was 'you don't waste anything.' We did canning, freezing, butchering—those sorts of things. Grandpa used workhorses until the mid-1950s, and of course, the horse manure was the fertilizer. So conserving was the norm." Maggie's parents took over the farm when her paternal grandparents retired, but when Maggie's father died, her grandpa Fred Small stepped back in. "Grandpa was the one who pretty much raised us, while mom went back to school to become a teacher," she said. Maggie and her four siblings learned about work very young. "Grandpa taught us the work ethic. My sister, Donna, was older so she got to do the outside work. I did most of the housework and all of the cooking, and my brothers and I did a lot of the gardening. We had a huge garden, and Grandpa had hoes for all of us, even a little one for our littlest brother."

Maggie did find time to ride, however. Her grandpa would send her out to the pasture to bring in the work horses. "I'd climb up their legs and run 'em on home. He'd get so mad because they were worn out before they ever got there to work. But that's how I learned to ride," she said. Fred started the kids on ponies. When the older kids outgrew them, he got them a little quarter horse named Ginger. Maggie's sister monopolized Ginger, though, so a favorite uncle gave Maggie a horse named King. "That was the horse I rode bareback while growing up, racing him at the fairs. He was a really good horse," she said.

Despite her love for her life on the farm, Maggie didn't have any expectation of staying there. She decided to become a stewardess after hearing about it at a high school career day. "I thought it would be kind of fun, and at the time, it was glamorous to get away from home." Her choice kept her moving around the country for the next several years. Because the speaker had recommended that young women begin with nurse training before becoming stewardesses, Maggie attended a licensed practical nurse training program at the Mayo Clinic. She and a classmate then moved to Colorado. As she explains, "It was 1962, and everybody else was going to California, so we decided we would go to Denver." After spending about a year in Denver, Maggie moved to Florida, where her high school sweetheart planned to go to school. He ended up going back to Minnesota, but she stayed and worked at the University of Florida Hospital for several months and then signed on

HELEN HAMMOND GIBBS
GARFIELD COUNTY CONSERVATION DISTRICT

Raised on a sheep ranch in northeastern Garfield County, Helen Hammond started working at the county courthouse in Jordan soon after high school. She eventually was elected county assessor and served for several years. After her marriage to John Gibbs in 1959, she lived in town during the week and at the ranch on weekends. She moved to the ranch full time a few months before the birth of their second surviving child. Helen passed away in July 2017.

"My mother was only about two years old when she came over from Scotland. Her father was here for a year before she came with her mother and a friend. They'd never been away from home before, but they found their way through Ellis Island and got on the train and came out to Montana. It always amazes me how they found their way here. In those days, people would come over to herd sheep and then take sheep in payment instead of wages. Her father worked with his brother until they had a little band of sheep, then he sent for his wife and kids. My father came from Illinois. His father died when he was quite young, and his mother remarried. I think he was probably about ten to twelve years old when they moved out here to some place south of Miles City. Then his mother and stepfather divorced, and she homesteaded over in the Flat Creek country, about 1916 I think, and raised her kids on her own. I always thought I'd do the same thing as my folks did. I suppose what I like most about ranching was that you're your own boss. And I always like lambing and calving too. I think there's more variety to ranching than there is to town life. In a way, you'd think there was more to do in town, but when you're working with livestock, there's always something new coming up. Sometimes it's good, and sometimes it's bad."

with United Airlines. After training in Chicago, Maggie spent the next years flying out of San Francisco, Miami, Denver and other hubs. "We would be based in one location for at least six months, and then we could move on to another hub if we wanted to," she said. "The work was nothing like it is today. Even on a one-hour flight, we would serve a hot meal and cocktails. The liquor was free, and on every food tray was a little pack of cigarettes. So a lot different than it is now."

Maggie Julson was a stewardess for United Airlines from 1964 to 1979. She was twenty-six years old in this photo. *Courtesy of Maggie Julson.*

She and her sweetheart finally married in 1968 when the airlines changed their stipulation that stewardesses had to be single. After the marriage ended in 1975, Maggie settled in Chicago. "My sister lived in Iowa then, and I would go visit her. That's where I met my second husband," she said. He had a farm that was about one thousand acres, along with a one-thousand-head feedlot. Maggie lived on the farm and commuted to Chicago for work until 1979, when she quit the airlines to move to Montana. "My second husband came out here to hunt each fall. He wanted to get off the farm and loved the Big Hole area, so we moved there for a couple of months and then bought the ranch near Sheridan," she said. They ran cattle for a few years, and Maggie was able to implement numerous conservation practices there to improve the land, but the relationship was difficult. When the couple divorced in 1987, the ranch was on the brink of foreclosure. "I stayed as long as I could, but I couldn't keep up the payments," she said. "I tried to work with the FHA to get a loan. At that time, though, I think that the fact that I was a woman on my own was one of the reasons I didn't get it." Maggie was on the ranch for about a year after it went into foreclosure. During that time, she was introduced to the man who would become her third husband. They had a lot in common, as he was a pilot for a commercial airline out of Denver and wanted to return to his home state of Montana. The couple ended up in Reed Point both because the ranch was affordable and because it was close enough to Billings for him to commute to Denver. "Basically, my

husbands were why I ended up where I did," she said. She sums up her marriages with two thoughts: "I couldn't seem to get beyond seven years," and "I learned a lot."

Now in her seventies, Maggie is still very much active but making changes to make life easier. She has cut her flock back to about one hundred ewes. "It's still quite a bit of work for one person, but my friends help. The winter months are the easiest. Granted it's cold for feeding, but I don't have all the rest of the work to do. I take my time and have it set up so that I don't have to start up the tractor every day, which makes it nice," she said. Maggie's sister, Donna, lives on Small Ranch in an apartment Maggie built in the late 1990s for extra income. Donna's rent and the rent Maggie gets from leasing a pasture to a neighbor give her enough extra to make periodic improvements, such as the addition of a big hay barn. Before the barn was built, she protected the hay with tarps, which was a frustrating and work-intensive process. "You can't feed sheep moldy hay when they are pregnant because they will abort. The tarps were heavy and the wind would still blow them off, so the barn has been a great improvement."

Overall, Maggie is optimistic about the future of agriculture and, in particular, the growth in the organic market: "I think that people are becoming more aware of where their food comes from. More and more people are going straight to the farmers to get their food and even their meat. The people who are eating the food should have input into the process. In fact, I think they have a responsibility because they can change things faster than individual small farmers can. The small farmers are doing their part, but there are humongous feedlots and operations, and there aren't enough farmers to demand changes, like saying, 'I'm not going to buy GMO seed,' for instance."

Maggie also credits the sustainable farming movement for creating more opportunities for women in agriculture. The biggest challenges she sees for both women and men are the high prices of land and equipment. "It's difficult for young people to get into it unless they have another source of income. It helps that more people now have work that they can do from home. I'm hoping that more young people can get out of the cities onto small acreages where they can improve their lives and the land." Maggie knows that that is easier in places like the Midwest than it is in Montana. "You just don't put a seed in the ground here and hope it grows. It takes work."

Small Ranch will pass on to her siblings. One of her nephews is very interested in agriculture and returns to the family farm in Minnesota whenever he can to help his uncle. "He'll do something in ag somewhere,

Maggie Julson weighs each fleece after it has been shorn from the ewe, 1990. A fleece will weigh around nine pounds. Maggie has worked with the same shearing outfit every March for over twenty years. *Courtesy of Maggie Julson.*

but where I don't know. He was raised in Minneapolis but he was born loving agriculture, and I'm hoping there are more like him," she said.

In the meantime, life is good. "I like the peacefulness the most," Maggie said. "The land becomes a part of your being. Everything is alive, whether it's the grass or the trees—and definitely the animals. There is just an energy that you get from it. It's not all smooth by any means. Sheep get killed by predators, the weather hits. But those are things in life that you accept. It is just part of living in agriculture, and the rewards far outweigh the challenges."

"People Need to Know Where Their Food Comes From"

Pauline Adams Webb

BROADWATER CONSERVATION DISTRICT

She didn't know it at the time, but Pauline Adams sealed her fate as a future Montana rancher the day her dad hollered up the stairs to her that "there's a cowboy here and he wants to take you for a ride." It was spring 1940, and Pauline was nineteen years old. Having just earned her teaching certificate, she was living with her family in Taylor County, Iowa, near Blockton, and waiting for the fall term to begin. In the meantime, life had become a little more interesting. Twenty-one-year-old Earl Webb was in town with his mother and younger siblings to visit his grandmother who lived nearby. "She had asked me if I would help entertain the children, and I said yes, I'd be glad to," said Pauline. "So we did lots of things, roller-skating, swimming, festivals. It was always a group of people going out and having fun. But the night before he left, Earl came over and said he'd like the two of us to go for a ride. And no, we did not neck, we talked."

Earl ended the evening by telling Pauline to look him up if she was ever in Montana. She agreed, thinking it was unlikely. Then a few weeks later, Earl's grandmother asked Pauline for another favor. She wanted to visit her family in Montana but couldn't travel alone and would Pauline go with her? By the time Pauline returned to Iowa that fall, she was engaged. Because she intended to teach the school term, Pauline turned down Earl's offer to buy her an engagement ring, afraid that it would jeopardize her job. Earl gave her a watch instead. "In those days, Iowa didn't allow married women

to teach because the man was supposed to be the breadwinner," she said. "I was going to teach school for forty dollars a month." It didn't last long. "At Christmas time, Earl came out to Iowa again, and he said, 'I don't want to wait. I want to be married.' So we got married, and I lost my school and came to Montana, this beautiful, beautiful state."

Pauline would cut a wide swath in her new home. In addition to ranching, she filled her life to the brim by teaching school in Crow Creek and Radersburg, leading a 4-H group and participating in many, many organizations, including Cattlewomen, the Red Hat Society, a local book club, her church groups and more. Her three children would come to describe her as a force of nature, particularly when pursuing her passions, agriculture and education. As a charter member of the Agriculture in Montana Schools program, Pauline loved speaking to students about farming and ranching and would put considerable thought into her presentations. Just four years before her death at age ninety-six, Pauline was visiting family in Arizona for Christmas and took a side trip to a pecan orchard. She wanted pecans in different stages of development so she could show the children in the Townsend Head Start Program the lifecycle

Pauline Webb was an active member of the Red Hat Society for many years, 2015. *Courtesy of Denise Thompson, Broadwater Conservation District.*

of a nut. Her presentation was a big hit with the students, particularly the pecan pie Pauline brought them.

Pauline's life in Montana began on the Webb family ranch in the Crow Creek Valley of Broadwater County. Earl's family came to Montana in the mid-1860s after his grandfather, George Webb, was urged by a friend to come West where there were "jobs aplenty." George got off the train at Toston with thirty-five cents in his pocket, and within a day, he managed to find his friend and a job. Earl seemingly inherited that initiative. After bringing home his bride, he quickly found work in the iron ore mines near Radersburg because he believed that a married man shouldn't be dependent on his family. But working underground lost its appeal. "When spring came, he was like a gopher," said Pauline. "He had to come out of his hole. So Earl got a job herding cattle for the Broadwater Stockgrowers Association." That job came with a one-room cabin in the mountains. "For a girl who'd been in town all her life, it was very different," she said. "We rode horses every day, fixed watering troughs, cut brush and made trails, salted and moved cattle—it was a wonderful, wonderful experience."

The couple returned to the Webb ranch in the fall and lived there until 1945, when a family friend made them a life-changing offer. Warren Parker had just been elected Montana District Court judge and needed a ranch manager, given his new career. This job also came with a house—one that had indoor plumbing and a generator in the basement. "So we moved down there," said Pauline. "We were there for sixty years on that ranch. Warren put it in his will that if the ranch was ever to be sold, we would have first opportunity. And, Lord willing, we put away money for that day, and when that day came, we were able to buy it. We were ranch owners pretty close to forty years."

She and Earl would name their place the 54 Ranch, after a brand they owned. The nearly five-thousand-acre ranch was about twenty miles south of Townsend. In addition to the dairy herd Earl had on his parents' ranch, the couple ran cattle and raised hay, native grass and grain for feed. For the most part, Earl handled the outside work and Pauline took care of the inside and their children, Jim, Susan and Ray. Sometimes, the inside and the outside work overlapped. Despite her enthusiasm for riding during those early months in the mountains, Pauline didn't develop a strong attachment to horses, but she did love the newborn calves. It wasn't uncommon during a particularly hard winter for some of them to end up in the basement for bottle feeding.

PEGGY GRAVELEY KUDE
BROADWATER CONSERVATION DISTRICT

Peggy Kude grew up a "townie" while her father commuted from Townsend to his family's homestead a few miles away. She attended Western College in Dillon for a year, dropping out after her father's death. A few months later, in September 1951, the district superintendent of schools offered Peggy a teaching job in Lombard, a few miles outside of Townsend.

"It was a one-room schoolhouse with a piano. I taught three little boys; their daddies were railroad workers, and the mommies were homemakers. The little boys were in grades one, five and eight. I was terrified. I lived in a boxcar, which had been remodeled into the semblance of a house. There was a kitchen area with a sink with a pump that I had to pump for water, and there was a bedroom. The bathroom was outside. Needless to say, at nineteen years old, I was not thrilled with my arrangement, although the students were darling boys. I was there from September until Christmastime. Then this young solider came to visit his father, who was a railroad foreman. We got together, and I ended up quitting my job and getting married and moving to Tacoma in short order. My parents were born and raised in the Townsend area. When my granddad wasn't up to doing the work, my dad and one of his brothers went in together and bought the ranch. It was on what would be now the north end of Canyon Ferry Lake. We had cattle there. We also had a hay farm at Canton. Growing up in rural Montana gave me a sense of community, maybe more than I would have otherwise, and responsibility. My dad came from a very protective mother. My mother, on the other hand, was very independent and believed that you got what you fought for and to take care of yourself. We got that independence from her."

Pauline's garden was another passion. "We grew practically all of our vegetables," she said. "One year, we planted squash, and the kids also wanted to plant gourds. They pollen-crossed, and we couldn't eat the squash. But you know, picking a ripe tomato that's been kissed by the sun—there's nothing better." Tomatoes and beans were canned, peas and corn frozen. There were also cucumbers for pickles. Pauline made both sweet and dill

pickles because she liked dill and Earl liked sweet. To augment the fruit from their large orchard, Pauline would also buy bushels of peaches. "My jewels were my canned fruit."

The orchard was the setting of one of the Webbs' favorite stories. The whole family had been visiting the neighbors, and when they got home, Earl told Jim to bring the cows in for milking. "Jim came back and said, 'Dad, those cows are acting awfully funny. One of them fell down,'" said Pauline. "Well, we had them in the orchard, and that year we had a very, very good crop of apples, and of course, there were some on the ground. The cows had eaten those apples and become a little bit intoxicated, so we didn't get any milk for three days."

Pauline Webb was thirty-one years old in this photo and had been married for eleven years, 1951. *Courtesy of the Webb family.*

If Pauline ever had any doubt about ranch priorities, she was reminded when Susan was born. Earl's diary notation for the day was that the milk cow had a calf, and "Oh, by the way, Pauline had a baby girl." She was always grateful that she was able to raise her children on the ranch. "I am very, very fortunate that I got to raise my children there and that they didn't have the temptations that some people have in a town or city," Pauline said. It wasn't that she wanted to isolate them. Pauline and Earl were both avid readers and expected their children to be as interested and informed as any city kid. They just didn't need to participate in the things their parents didn't agree with. As it was, there was plenty to keep them busy. "I don't believe that I ever heard any of them say they were bored," Pauline said. She was proud that they grew up knowing the value of hard work. Pauline didn't have much patience for underperformance. In her mind, you made sure to be prepared, and if you failed, you learned from it and tried again. And if you had something good, you worked to make it even better. "Life is what you make it," said Pauline. "If you dislike something, do it anyhow and do it the best you can. I think my children learned that."

They were taught that life wasn't stagnant. Pauline and Earl changed with the times. After running Herefords for years, for example, they moved to a Black Angus/Hereford cross because that's what the market wanted; buyers

JANET CAMERON ZEIG
MEAGHER COUNTY CONSERVATION DISTRICT

With the exception of a short time in Denver, Janet Cameron Zeig spent her entire life in Meagher County. Her early years were spent on her grandparents' ranch north of Martinsdale and then on her parents' ranch along the Musselshell River. She and her husband, George, moved to the Smith River Canyon in 1960. After the couple divorced in 1984, Janet ran her own operation there until her death in February 2018.

"It was just the two of us, and it was a pretty big place in terrible, terrible shape. There was no hay on the place, and we had about 150 head of cattle. A mountain range started straight up from the bottom of the canyon right across the river from us, and there were meadows and benches up there 'til you got clear to the top and then there was a lot of open, huge parks and what not. So we would put all the cattle over there, and of course, they would go up where the grass was. George would ride over every day—and it was steep, steep country—to find all of the cows and see what shape they were in. The ones that were falling off, he'd bring home, and we'd buy a little hay. We'd keep bringing some home and try to get them all off the mountain before calving. Spring, things start opening up, and we would push the cattle out into some pastures where the green grass would start coming first. Then I would take care of them, ride out every day and check for new calves and everything like that, while George was trying to get ditches cleaned and burned and fences up. We did that for a long time. Finally, a neighbor talked us into going into the outfitting business. We started small, just half a dozen hunters at a time, but we kept it up for quite a few years and we got pretty big with it. I accepted the hunting because we desperately needed the income to hold everything together and improve the ranch. We had to build all new fences. We built a new shed. We built a new barn. We really got the hay meadows in great shape and had a beautiful bunch of cows. I've never resented or complained about working. My people didn't; I never heard any of my family complain. You just accepted your life and did what you could to make it better."

liked that they filled out faster than the purebred Herefords. Earl wasn't fond of Black Angus, given that a neighbor's Black Angus bulls were notorious for escaping their pasture and visiting his Herefords. Putting personal preferences aside, however, he and Pauline followed the market and were very successful.

Stewardship was a matter of course on the 54 Ranch. To avoid overgrazing, the herd was kept to the size they could feed. Pauline also respected Earl's care with the cattle. "Even though it's fun to rope a cow or calf and put a brand on it, he always ran his through a chute. He thought it was harder on the calf to rope it and throw it on the ground," she said. The Webbs never participated in any government farm program. Earl had strong feelings against it and wasn't shy about sharing them. In fact, when asked one time by an agent to plow under part of his wheat crop, Earl told the man to "get the hell off my ranch. I am growing this for my own benefit. None of it ever goes to market, and it is none of your business." Although Pauline didn't appreciate the language, she agreed with the sentiment.

Earl also believed that you didn't need anything that you couldn't pay for in cash. The Webbs' good reputation helped them budget. For example,

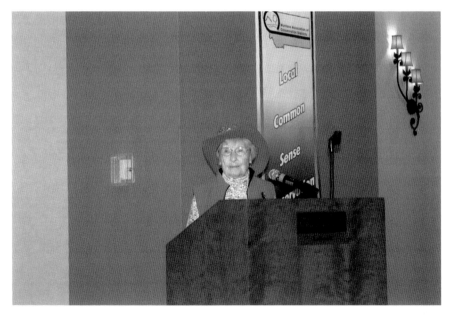

Pauline Webb speaking at the Montana Association of Conservation Districts' 2012 annual convention in Kalispell, 2012. *Courtesy of Denise Thompson, Broadwater Conservation District.*

Gloria Van Horn Sundquist
GLACIER COUNTY CONSERVATION DISTRICT

A charter member of Montana Women Involved in Farm Economics, Gloria Sundquist was a renowned advocate for conservation before passing away in August 2017.

"In my earlier days, I was active in many organizations, mostly ones in agriculture. I believed in educating kids and adults in weed control. I have been recognized for the weed placemats that helped promote the education of weeds. My neighbor and very good friend, Hazel Johnson, and I would go out spraying weeds on a regular basis. We would focus on knapweed, but there were many other varieties that got sprayed also. You can't let them get out of control, or they will take over. Then you won't have a crop. Taking care of the land that feeds you is extremely important."

they were able to make a once-a-year payment for the periodic gasoline deliveries to their onsite tank because the dealer knew they were good for it. Though never a big spender, Pauline was sensitive to perception. So when she and Susan went to Helena to shop, they would go into Fligelman's department store and ask for a big shopping bag. Everything they purchased went into it, and Earl saw only one shopping bag carried out of the car when they got back home. Pauline never lost her delight in getting a good deal, and in her later years, she and Susan would have contests over who could get the best bargain when shopping. Pauline wouldn't hesitate to pull out all the stops. She often told the salesclerks about the contest and urged them to help her win by taking just a little more off the markdown. And more often than not, they did.

Earl passed away in 2001. Pauline leased the ranch but continued to live on it for another few years until her children realized that she was making the forty-mile round trip to Townsend sometimes three or four times a day and convinced her to move into town. Although she enjoyed her years in Townsend, offsite leasing wasn't a good experience. The tenants failed to take care of the ranch, and it was painful for Pauline and her children to see the place they loved fall into disrepair. Eventually, Pauline sold it.

Pauline's children convinced her to move again following a health scare a few years later, this time to Missoula, where Susan lives. All three of them had rushed to Helena when they learned that their mother was in the hospital on hospice care. Pauline was awake but not responsive, and as Jim, Susan and Ray sat by her bedside, they talked and shared memories of the good times on the ranch. On the third day of their vigil, all of a sudden, Pauline sat up and told them, "I'm hungry." Astonished, they asked her what she would like to eat, and she said, "Well, I'm pretty fond of Applebee's Chinese chicken salad." Pauline got her salad and lived two more years—although, opinionated as ever, she chided her children for not just letting her die.

Pauline was an avid supporter of the Montana Women and Agriculture oral history project. She eagerly participated in several related community events as a way to share her story and help people bridge the gap that she believed exists between those who buy their food in the grocery store and those who produce that food. "People need to know where their food comes from," she often said. "It's important." Pauline passed away in November 2016. The day before she died, she decided that she wanted to dance. And so she did.

13

"We Are Simply the Keepers of the Land for Now"

Celeste Ward Schwend, Linda Schwend Finley and Dana Weatherford

CARBON CONSERVATION DISTRICT

Linda Finley was delighted when a regional cattle buyer offered to buy her calves sight unseen a few years ago based solely on her family's reputation. But she still wanted him to know more about who he was dealing with, so after the contract was signed, she invited him to visit. It was a smart move. The buyer later told her that he'd known he'd made the right decision as soon as he drove into the ranch yard and saw that the lawn was mowed, the sprinklers were going and everything was well cared for. "He was confident that the calves were going to look as good as the place looked," said Linda. "I'm very proud of that—and that he's bought our steers every year since."

Linda's family has been running cattle on this ranch since the late 1800s. Located three miles southwest of Joliet in Carbon County, the ranch has always been home to multiple generations. Just as Linda grew up there with her parents and grandparents, so too did her mother, Celeste Schwend, and her daughter, Dana Weatherford. Grounded in the very dirt beneath their feet, these three generations of women share a deep conviction for their way of life. But their stories are distinctly their own.

Celeste is the matriarch and the heart. Born in 1931, her earliest memories include the struggle of trying to make it during the Dust Bowl. Family legend has it that her parents, Chris and Rose Ward, produced a little bootleg whiskey along with their cattle and a few crops to make ends meet. "It was the Dirty Thirties and everybody was really, really poor," said

Linda Finley and her mother, Celeste Schwend, 2017. *Courtesy of Ross Campbell, DNRC.*

Celeste. She and her younger sister, Margaret, did their share by picking up windfalls in the eight-acre apple orchard. "Grandpa paid us fifty cents a box for the apples we picked off the ground, and my folks would peddle them to stores. We also made cider to sell, gallons and gallons of cider."

Celeste's mother was very much an outdoors woman. So, although Celeste remembers being able to ride her horse and the thrill of driving the stacker team during haying season, she and her sister took on the cooking, cleaning and other inside chores at an early age. After graduating from high school, Celeste went to work in Joliet to help cover household costs until she left the ranch in 1952 to marry Chester "Chet" Schwend. Chet's family spent winters in Bridger and the rest of the year at their ranch on Sage Creek in the Pryor Mountains. During their first five years of marriage, Chet and Celeste lived at the Sage Creek ranch as well as at a cow camp in Big Horn County. It was a harsh existence, and when Celeste and Chet had a chance to move back to the Ward ranch in 1957, they were happy to go. For Celeste, it was returning to the place she loved. For Chet, who had four brothers, it was the opportunity to eventually run his own operation. Both were ready to build a life there for their four small children. "There is just something wonderful about living here," said Celeste. "It is a special place."

As before, any extra cash was critical to the ranch's success, and eventually, Celeste started picking up temporary work in Joliet. In January 1968, that led to a part-time job in the Carbon Conservation District office. At the same time, she continued to manage her family and ranch chores. "She had a job in town, cooked huge meals for huge crews, grew a massive garden, did all of the ranch's bookkeeping—and did it all with a lot of class," said Linda. "She's a grand, grand lady."

Like her mother, Linda's love for the ranch would bring her back home when she needed it most. Linda describes her childhood as cash poor but full of joy. "In the beginning, my brothers and sister and I were raised in a little itty-bitty house in the barnyard, with two bedrooms and no bathroom," said Linda. "We went to school in Boyd through sixth grade, which was your basic one-room schoolhouse, then we went on to Joliet for junior high and high school. We lived with one set of grandparents across the road and spent the summers with our other grandparents in the Pryors. I thoroughly enjoyed it all."

Linda grew up competing with her two elder brothers for acceptance and respect as a ranch hand. She gave it her all. "As a young girl, if we were going out for a ride, my horse was caught and saddled and tied in the trailer, and I was asleep in the pickup before the others showed up. Because they were not going to leave me, that's all there was to it. I did every kind of job that I could just to help out, and if I didn't know it, I learned it. And if I couldn't do it the way they did it, I would figure out a way that I could do it."

She credits both her grandmothers for her love of working outside. "Grandma Rose was in the middle of anything that was outside, much

Linda Finley and her daughter, Dana Weatherford, 2012. Dana won the Montana Star Farmer's Award, a statewide competition sponsored by the Future Farmers of America. Judging criteria included ownership of a cattle herd, agricultural experience and job experience. The project spanned her freshman through senior years at high school. "It was the coolest thing when they called my mom on stage during the award ceremony to have our photo taken together," Dana said. *Courtesy of Linda Finley.*

like me," she said. "And I loved being up on Sage Creek in the summers. Grandma and Grandpa Schwend would come and get me when I got out of school so I would be up there when everybody would gather there on the Fourth of July. In the afternoon, when the crowd was beginning to go home, I would hide so I wouldn't have to go home." Part of the appeal of the Pryors for Linda was her Grandma Schwend's band of sheep. At the time, the lamb and wool crops accounted for a big part of their income. "My grandpa and my uncles hated them, but they couldn't deny Grandma her sheep because of the money. She had those sheep until she could no longer actively take care of them."

Linda first left home at fifteen when she had an opportunity to spend the summer working on a dude ranch in Cody, Wyoming. It would prove to be a pivotal experience for her. "I don't know who I would be today without that job," she said. Linda worked in Cody during the summer until she graduated from high school and then went to work at the dude ranch full time. The owner was more than generous in teaching Linda everything she knew. "I learned a billion things, but mostly she built up my confidence by showing me what I could do, and I love her for that."

That confidence carried her forward. Linda returned to Joliet and married into the Weatherford family, who live just four miles from the Ward ranch. When the marriage ended, she moved back home with nine-year-old Dana. Today, Linda says, "I have quite possibly the best job in the world because I can do a hundred different things in a day." She and her brother, Doug, manage the ranch with the help of their respective spouses, Mike, whom Linda married in 2014, and Pam. A partner in all decisions, Linda is also the official gofer, knowledgeable enough to take care of whatever business has to get done in Billings. "I also help with the calving, haying, irrigating and the harvest, and feed everybody in the process," she said, adding that "it was all taught to me by my grandmothers."

Linda describes Doug as the head that she, Mike and the full-time hired man pivot around given that he has been involved with the day-to-day management the longest. "He might say, we need to be working towards this, and we respond with ideas about how to go about that," she said. It is very important to both siblings that they discuss issues rather than argue about them. "We work diligently at it not being an argument. We've had generations behind us that thrived on that. Doug and I don't."

The family has about eight hundred acres of farmland and raises malt barley and winter wheat to sell, as well as hay and corn for feed. All of their summer pastures are leased land on the Crow Indian Reservation via

BONNIE NORSBY KRONEBUSCH
PONDERA COUNTY CONSERVATION DISTRICT

Raised on her parents' farm near Valier, Bonnie Kronebusch and her husband, Paul, farm on his family's homestead near Conrad. Conservation has been a priority throughout her life.

"I have been with Paul going down country roads, and I'm driving and he's on the tailgate of the pickup and we stop so he can dig out goat's beard. It is a noxious weed. You take care of the land around you, whether it's your land or the barrow pit. You just do. We are also aware of the good conservation practices in this area, so it's hard when you see leafy spurge out of control and not being taken care of. It's not on your land, but it needs to be taken care of. I think conservation goes hand in hand with the work ethic. Both of our children, when they see something that needs to be done or changed, they're not afraid to step up and do it. Whether they had to help clear land or make sandwiches for the poor or whatever, they know where food comes from and how hard it is to get it. They appreciate when things are done right and good conservation is being utilized."

agreements their father first signed more than fifty years ago. "We lease about ten thousand acres, and it is tremendous grazing," Linda said. "We have good water there, good grass, and it just sits where most years it gets nice moisture for the grass to keep coming. It's just an all-around great climate for cattle."

Linda and Doug initiated several changes over the years as they took on more and more responsibility for the ranch, including upgrading equipment for better efficiency, such as adding a hydraulic calf table and moving from Hereford to Black Angus cattle. They are also more demanding of their herd. It used to be that as long as a cow produced a calf, she could stay. "Doug and I don't subscribe to that whatsoever," Linda said. "They need to produce a quality calf, and if they are not up to the task, we sell them." They like moderate-sized cows with good temperaments. "A cow is maturing into herself by about four years old. At that point, they sometimes get hard to work with, meaning that they can hurt somebody, and then they have to go."

Physical issues are also a consideration if it means that year after year the cow needs to be helped or put in a chute to get the newborn calf suckling. "That is not good if that calf happens to be born in ugly weather. They have to get up and find that first meal."

Advances in land management are also under way. "Making advances in agriculture is a tough deal. It has to be done for conservation and the betterment of the land, but it's expensive. Being able to keep the balance of that is a tough job," Linda said. In recent years, the family has updated its irrigation system by moving to pivot sprinklers. They were also moving toward no till drilling but hit a snag when they ended up with ergot in their barley. "It's a little black fungus that has brought us a whole new level of agriculture," Linda said. "It happens when you are not deep-plowing your soil, so we are learning the balance. Obviously, it should be done from time to time on irrigated ground."

Comfortable in her current role, Linda doesn't minimize the hard work it took to get there. It was particularly difficult for their father to let his children take over management of the ranch. "Actually, he fought it tooth and nail to the day he died," she admitted. In addition to not wanting to lose control over the ranch, she believes that part of the problem came down to generational attitudes. For example, Chet viewed the bank as the enemy while Linda and Doug see it as an ally. "Dad looked at everything like it was against him, and sometimes I think he thought his kids were against him too. But he was tough, oh my lord, he was tough," said Linda.

She speaks frankly about the struggle with her dad because she wants other families going through it to know that they are not alone and that hopefully they can all learn how to do a better job with the next generation. "Giving responsibility to the next generation is a hard thing, it just is. It can only happen with a lot of communication," she said. That communication shouldn't only be about succession planning and expectations. Linda believes it is also vital to tell the next generations about those who worked the land before them, what they did and how they did it. Not only will that provide practical knowledge that could help with future decision making, telling those stories builds a bond between past and future as well. And it is that bond that strengthens the next generation's commitment to securing that future.

"I think that my brother Doug and I have to work hard to keep everything together and preserve our past for it to go on," said Linda. "To even say that chokes me up a little because I feel very strongly about it." She sees it as a matter of earning that opportunity. "It's our turn to give it our best shot but

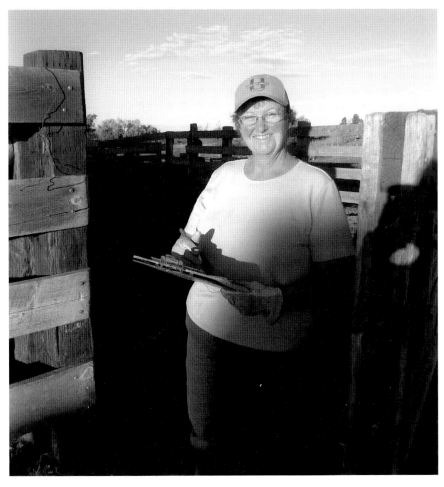

Linda Finley collecting cattle information, 2015. The family checks tag number, gender (heifer, steer or bull), brand and owner (family member) each spring and fall to ensure that all animals counted in the spring are there in the fall. *Courtesy of Ross Campbell, DNRC.*

I don't feel that we deserve anything. I think that Doug and I have earned a shot at it and that Dana is working at earning her shot at it."

Although Dana no longer lives at the ranch, she is there nearly every day working with the family as well as taking care of her own growing herd of registered Red Angus. Like her mother, Dana doesn't hesitate to speak frankly about what matters to her. She decided to run registered cows because she likes to be selective and focus on breeding characteristics and parentage traits, but she also wanted to separate herself from the family operation. "I'll be honest—family ranching is far from easy. By having my

TRACY GOERSS HENTGES
VALLEY COUNTY CONSERVATION DISTRICT

Tracy Hentges served on the Rangeland Resources Executive Committee for six years and the Valley County Conservation District Board for fifteen years. She and her husband, Jerry, ranch north of the Missouri River outside of Frazer. They grazed cattle thirty miles north of their irrigated and dryland farm until deciding to consolidate their operations and let go of the leases.

"We usually like to start calving in the middle of April and be done by the end of May. That way, they're done by the time we start farming. Irrigating season is one of my favorite seasons. I get to go out and be by myself and see the early morning sunrises and the evening sunsets. I spend most of the day gone, chasing water, trying to lead it around the fields. If it's haying season, I'm swathing, and Jerry's raking and baling behind me. Wintertime is pretty much quiet; all I have to do is go out and feed the critters. Then I do a lot of sewing. I'm going to miss the grazing leases. There's a hill we call our Lookout Hill, where we can see almost the whole grazing area and see whitetail deer and antelope running around. We put in I think six and a half miles of water pipeline up there and drove three wells and put in six water tanks. When we first picked up those leasing units, they were really overgrazed so throughout the years we've been rotating. Every year, there's always grass left over for the next year. To produce something, you have to take care of the land that you are producing it off of. A lot of people don't seem to understand that. They want to keep building bigger and bigger cities, and get rid of the farmland or grazing land. One of these days there's not going to be much available. I don't know what they will do for food then."

own cows that are a different kind of cow that is managed differently, I can do what I want to do, and I want that freedom," she said.

In her mid-twenties, Dana is unsure about whether she will return to the ranch for good. She is the only one of Celeste's twelve grandchildren and fifteen great-grandchildren interested in ranching at this point, but Dana is still considering her options. "I have so many different opportunities. I know that ranching will be one of them, I just don't know where I'll end up," she said. Now weed coordinator for Stillwater County, Dana has a degree in animal science from North Dakota State University and previously assisted with embryo transfer. Being able to do artificial insemination and pregnancy checks has helped her make connections for sales of her bull calves. She also makes the rounds of cattle shows. "I like the marketing side of it," she said.

Whatever she ends up doing, Dana expects to earn it. "I think I'm kind of in a different situation than most people my age who have an interest in ranching. My mom has definitely always been there to support me, but she hasn't been there to do it for me. If I wanted to show cattle, I had to do the work. So if I wanted to dive right in and do the ranching thing right now, I would have to pay my way." That doesn't intimidate her, she says, but she

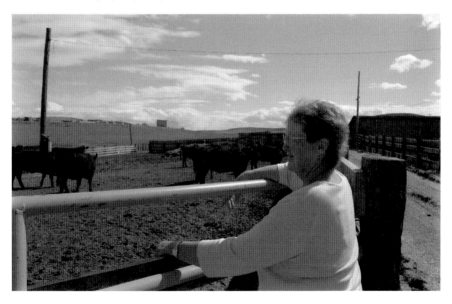

Linda Finley looks over yearling heifers who will become the future replacement stock in the ranch's cattle herd. The heifers are based on their composition, disposition and the parentage. "We bet everything on them with absolutely no guarantees what kind of mother they will be," said Linda. "Pretty is as pretty does, but looks are nothing if they are not a good mamma." *Courtesy of Ross Campbell, DNRC.*

wants to be sure it is what she wants to do—and that she would be able to do it her way. "I don't want to be in the situation where I'm wishing that I was doing this or that. I want to be doing what I want to do."

Dana credits her independence to how her mother raised her. Her close relationships with both her maternal and paternal grandparents are also central to her makeup. "Growing up, I was always with my grandparents, and it meant the world to me that they were friends and shared me," Dana said. "Leave it to my Grandpa Chet to say that my Grandpa Jim simply filled the holes that Grandpa Chet couldn't do. It's true." She calls her Grandpa Jim "her rock" and deeply admires how supportive the two men were of each other. "They were always there for each other as friends," she said.

Moving to the Weatherford ranch is one of Dana's options. Whatever she decides, Linda wants it to be her daughter's decision. "There's a place for her here if she chooses that; if not, that's fine too," she said. Proud of Dana's accomplishments, Linda believes that the family and the ranch have served as a strong foundation for both her and her daughter. "Basically, there is no such thing as falling flat because you will always have a great place to land."

That visceral sense of security is reinforced every time Linda looks toward the coulee behind Celeste's home. More than a century after her great-grandpa George Ward worked this land, it's possible to see the scarred remains of the fifteen-mile irrigation ditch he spent years digging with his team of horses. It was one of the first attempts to use flood irrigation in the valley, and George was so passionate about the project that he funded it on his own. "What he was trying to do for the people who lived in the valley is huge," said Linda. "It's the difference between dryland and irrigated farming, and he was willing to mortgage his entire place for that idea. I'm nuts about that."

Portions of Ward Ditch are in use today, although there was never enough drop in elevation to propel the water as far as his own ranch. "He was a hugely progressive man, and I like to think that my generation is still moving forward in keeping the land producing as much as it can while still maintaining it," said Linda. "We are not just sucking everything out of the earth and then leaving it. We are doing the best we can for it, and in turn, it does the best it can for us."

When the time comes for Linda and Doug to pass the ranch on, Linda will do so without regret. "My mom and I think alike on this," said Linda. "We are just simply the keepers of the place for now. Her parents kept it for her, my parents worked hard to keep it for my generation and I will do the same for the next with hopes that they will carry that on."

About Broadwater and Glacier County Conservation Districts

Broadwater and Glacier County Conservation Districts are located in Townsend and Cut Bank, respectively, and are among fifty-eight conservation districts (CDs) in Montana established by the state in 1939 to help citizens conserve their soil, water and other natural resources. Managed by unpaid, locally elected supervisors, the CDs work with landowners on local voluntary conservation programs that range from stream and river restoration to water quality–improvement projects to assisting urban areas through education, tree planting, park development and other conservation practices. Their work with agricultural producers is particularly important and includes projects to test and demonstrate farming and ranching conservation practices. In 1975, passage of the Montana Streambed and Land Preservation Act (the 310 law) gave the CDs the authority to review all proposed work in or near rivers and streams to minimize impact. More than thirty-five thousand projects have been reviewed to date.

The CDs have their roots in the Dust Bowl. As years of drought, wind and land management practices of the time culminated in the "Dirty Thirties," Congress established the Soil Conservation Service (SCS) in 1935 in recognition of "the national menace" of soil erosion. Since their establishment, the CDs have worked closely with SCS (renamed the Natural Resources Conservation Service in the 1990s) to set priorities and plan soil and water conservation programs. They are supported by the Montana Department of Natural Resources and Conservation and Montana Association of Conservation Districts, and partner with tribal conservation districts and other organizations to assist in conservation of Montana's renewable resources.

Index

Visit us at
www.historypress.com